IMAGES
*of America*

# ORANGE COUNTY
## A NATURAL HISTORY

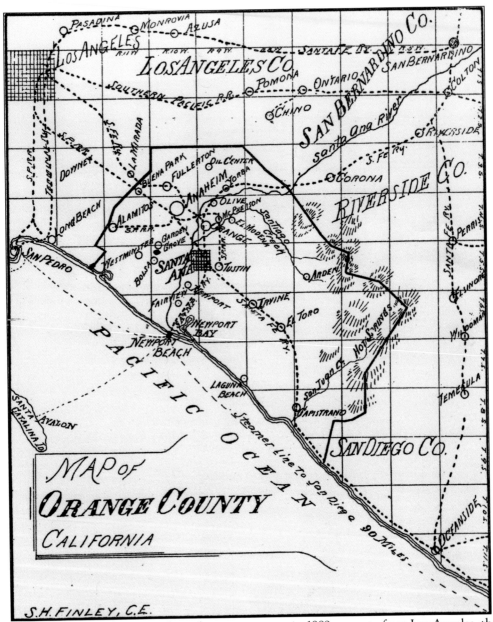

**WHERE WE ARE.** A few years after it became a county in 1889, separate from Los Angeles, the County of Orange published a small promotional booklet outlining the advantages of living here. This map was its centerfold. There was little Orange County, surrounded by large Los Angeles, Riverside, and San Diego Counties and the Pacific Ocean. Since then, Orange has grown—in population and in urban areas but also in natural preserves. (Author's collection.)

**ON THE COVER:** The road is rough—but ready. The vehicle is slow—but sturdy. The scenery is unexpectedly awesome. A Model T ventures through Orange County's Santiago Canyon about 1915. The vista ahead demands a camera stop. Fanning out ahead are a cliff of rock, a layer of pine forest, and a misty mountain. What other natural wonders could possibly lie beyond? (Courtesy Anaheim Public Library.)

IMAGES
*of America*

# ORANGE COUNTY
## A NATURAL HISTORY

Doris I. Walker

ARCADIA
PUBLISHING

Published by Arcadia Publishing
Charleston, South Carolina

Printed in the United States of America

Library of Congress Control Number: 2008942865

For all general information contact Arcadia Publishing at:
Telephone 843-853-2070
Fax 843-853-0044
E-mail sales@arcadiapublishing.com
For customer service and orders:
Toll-Free 1-888-313-2665

Visit us on the Internet at www.arcadiapublishing.com

*To three native residents of Orange County that left under pressure:*
*Grizzly Bear on land,*
*Southern Sea Otter at sea,*
*California Condor in the air.*
*You will always be part of our history!*

# CONTENTS

Acknowledgments                                    6

Introduction                                       7

1.    Alluring Coast                               9

2.    Winding Waterways                           27

3.    Backdrop Mountains                          45

4.    Rustic Canyons                              59

5.    National Forest                             75

6.    OC Rocks                                    91

7.    Wild Parks                                 103

8.    Preserving Nature                          113

A Natural Future                                 127

# ACKNOWLEDGMENTS

When you research and write about the spot where you have lived and have loved for nearly half a century, you still seek out natives who have lived their entire lives there. A must consultant on any historical volume about this county is very knowledgeable native Don Dobmeier. He has rightly risen to chairmanship of the Orange County Historical Commission—more than once. He knows the history of nearly every county nook and cranny.

Then there are the subject specialists. I couldn't create a knowledgeable chapter on local waterways and water movement without Steve Faessel, another Orange County native and author. He knows his historical stuff, having served as chairman of the Anaheim Utilities Commission in his lifelong hometown. For my chapter on Cleveland National Forest, I was lucky to have the advice of its former historian and author, James Newland, who now serves as a historian of California State Parks. He also shared forest photographs.

Librarians are a must when writing a nonfiction book. They are scattered throughout the county, ready to divulge or dig up whatever facts are needed. Jane Newell of Anaheim, and her library's extensive image collection, are a prime source in creating an Orange County pictorial history. OC Archives and the always helpful Chris Jepsen were invaluable, whether the need was a mountain peak or a creek scene. Thank you, too, OC Parks.

Another obvious treasure to us all is First American Corporation's historical photograph library. Bob Blankman is there to track down specific requests—like the vintage image I had seen of a young boy staring at a spouting artesian well. Bob found it. I cannot overlook my own California and Orange County reference book collections. I have added to them for each of the dozen books I have written. Thank you, other authors and photographers.

My all-around reviewer as the manuscript progressed was David Kristjanson—retired attorney, environmentalist, historical society officer, and well-read resource man. Thank you all for the parts you played while I glued the images and storytelling together with words. Thank you to my husband, retired U.S. Marine Maj. J. P. Smith, for living around my book deadlines and helping make the collecting of facts and images enjoyable outings. I would not have tackled this, my second Arcadia Publishing book, if it had not been for a persuasive and understanding editor, Jerry Roberts. *Salud!* Let's hope the readers feel that our time and energy have been well spent.

# INTRODUCTION

*In wildness is the preservation of the world.*

—Henry David Thoreau,
19th-century American author and environmentalist

Sometime in the past century—after the San Diego Freeway had cut through and cultivated southern Orange County with urban crops, but before many of today's residential communities had sprung up—the first cable television service arrived in a phenomenal facility built in the undeveloped southeastern wilderness of the county. Its grand opening took the press and its visitors along yet uncharted inland roads into previously unapproachable territory within the rugged backcountry landscape.

Suddenly there loomed before us a large, startlingly futuristic building. Its interior was even more amazing. Its walls were completely lined with action-packed television monitors bringing in live news happenings from all over the world. They danced, pranced, sang, yelled, and reported to us all at once.

On the roof of the building had been planted a forest of relay antennae and dishes that rivaled what now crowns the peak of Old Saddleback Mountain, which had been around forever without the need for skyward extensions.

This cable introduction party was an event to remember, since up to then the foothills that embrace us had prevented the intrusion of radio and television signals for most of the south county. Our world news came only on rabbit ears turned toward San Diego. Needless to say, we were impressed with this new equipment, knowing our lives had suddenly been added a new dimension.

As the pivotal evening drew to a close, we stepped outside into a completely different scene. The dark of night had settled down around the building, and no lights yet lit the parking lot or roughed-in landscaping. However, a full moon highlighted the distinctive silhouette of the Santa Ana Mountains and foothills. The cable signals had finally scaled them to reach greater powers in the sky.

Then, instead of the multiple monitor voices all talking in discord, a chorus of coyotes howled to the glorious moon their harmonious a capella song of the ages. They were out of sight but very near, seeming to surround the cultivated communications complex. It was as if they had been hired to remind us that—despite change or progress—these great open lands of the West and their native creatures were not to be overlooked or considered history. The moon and the mountains will hopefully be forever, and the masterful canine singers have only been limited in territory.

Fortunately, we still have the natural treasures. The friendly, rounded silhouette of the Santa Ana Mountains still dominates the horizon in this low-rise county. We still have unfettered views

of the ocean. We still have waterways and watersheds, which reward us with the sound of rushing water and waterfalls (in wet seasons).

We still have the diversity of the canyons with their distinct personalities and winding roads that add mystery to the edges of the urban scene. We still have the national forest and the scenic trails leading into its depths.

And now we have nature preserves, reserves, conservancies, and an array of wilderness parks, where coyotes still sing to the dependable changes of the masterful moon that rises regularly above the scene.

Here begins my tribute to Orange County, California's natural history. However, telling the story of an entire county in 200 photographs and captions becomes the equivalent of condensing a steaming bowl of stew into a packet of dried soup.

Space limits often dictate that one photograph must represent several lakes or trails or scenes. One native bird species may need to stand in for many. One protected site may become the example for several.

Since most of Orange County was under the ocean until a few eons ago, its natural history has even included marine life from the era when the sea reached the feet of the mountains.

We who inhabit or visit this county today have an easier trek into the wilderness areas than even a century ago. We have a network of trails and roads and directional brochures and books explaining the on-site natural wonders. Tours and excursions are available year-round, leading to unique encounters—tide-pool tours, kayak cruises, owl prowls, mountain walks—a lifetime of local adventures. And let us not overlook the vistas—to the sea, to the hills, to the wilds in the mountains and canyons. Venture out!

*Let us give Nature a chance; she knows her business better than we do!*

—Michel de Montaigne,
16th-century French Renaissance essayist

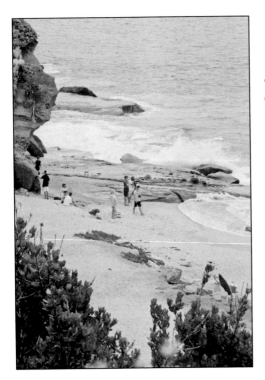

THE FRONT YARD SEA. Orange County, California, begins at the Pacific Ocean. Some devotees consider the sea an extension of the land, spending as much time as they can in or beside it. Aliso Beach in south Laguna Beach displays both the rocky high and low points of the coastal landscape. Though named Pacifico ("peaceful") by early Spanish adventurer Vasco Balboa for how it appeared off the equatorial belt, it takes on a different personality along Southern California. This book begins at the coast, then meanders along the waterways to and through the mountains and its canyons, ultimately reaching the national forest. After a hike through its wilderness parks, it closes with an overview of the forces committed to seeing that Orange County of the future retains all of these wonderful elements of its natural history. (Courtesy OC Parks.)

# One

# ALLURING COAST

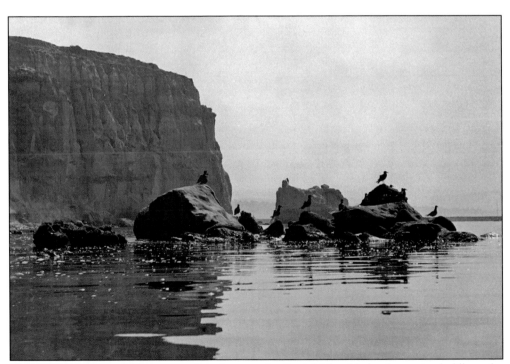

**NOTED LOCAL SCENE.** "The country here for several miles is high table-land, running boldly to the shore, and breaking off in a steep hill, at the foot of which the waters of the Pacific are constantly dashing. . . . There was a grandeur in everything around, which gave almost a solemnity to the scene," wrote author Richard Henry Dana, remembering his 1835 view of the Orange County point now named for him. (Photograph by the author.)

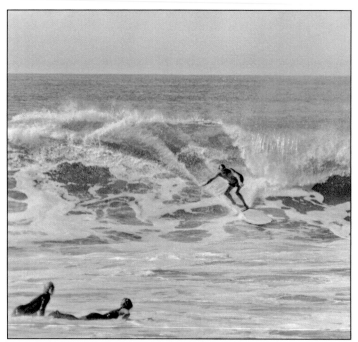

**THE SEA, THE SURF.** Along Orange County's 42 miles of coast, the sea's energy rises in motions best described in surfing terms. Cotton's Point, pictured here, forms a classic break at south San Clemente. It rises with big swells from the south, creating thick "bowling lefts." It "barrels" at lower tides. The estate of namesake Hamilton Cotton, investor in 1920s San Clemente, became President Nixon's Western White House. (Courtesy Surfing Heritage Foundation, Walter Hoffman Collection.)

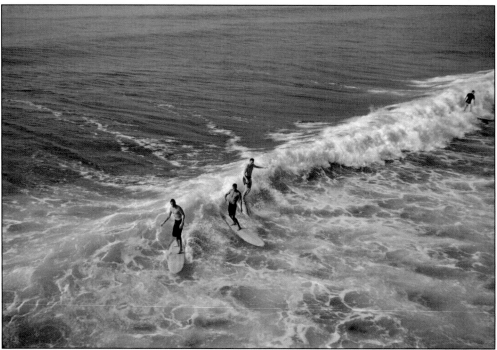

**HUNTINGTON BEACH SWELLS.** North Orange County's curving coast is relatively flat. The south end of Huntington is exposed to southwest swells, while the north is more west facing. This combination attracts special surf conditions. North of the pier invites larger swells; the state beach has smaller, longer swells. Sandbar formation also dictates the surf pattern. Surf City USA's beach break is dependable enough to schedule national championships. (Courtesy Surfing Heritage Foundation, Bob Pasqua Collection.)

10

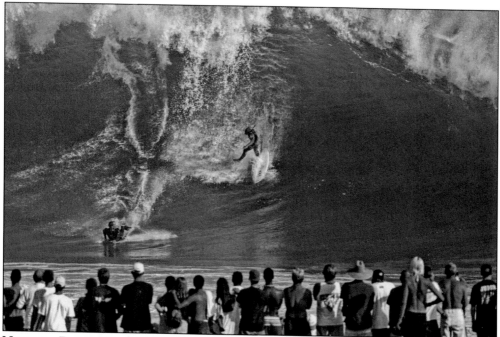

NEWPORT BEACH WEDGE. This legendary lesson in oceanography could be the best-known bodysurfing spot anywhere. It fosters a combination of two waves coming together, breaking with an astounding, unpredictable "humping effect." It can be dangerous, especially with surfboards. The addition of Santa Ana winds can turn reef breaks into roller coasters or flatten smaller swells. Watching the wave action itself is an awesome spectator sport. (Courtesy Surfing Heritage Foundation, Tom Keck Collection.)

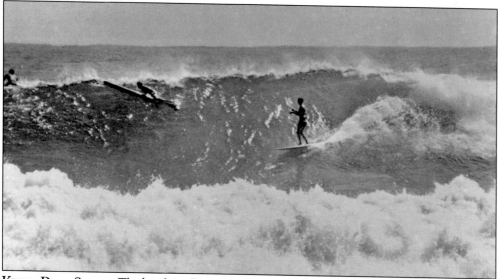

KILLER DANA SWELLS. The breaks at Dana Point were called Killer Dana, rising as high as 30 feet. When major storm swells wrapped around the rocky headland, it created a powerful right-hand ride at an angle to the shore. Underwater reefs and fast-changing tides spawned multi-personality waves. That surfing spot was stilled with construction of Dana Point Harbor, as were some breaks at Doheny State Beach. (Courtesy Surfing Heritage Foundation, Jim Gilloon Collection.)

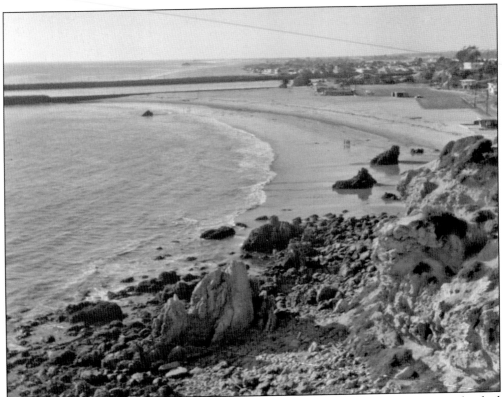

**THE SAND, BIG CORONA.** While washed by the same sea, the local coast takes on individual characteristics from the geology of its locale. Sand is the ultimate refinement of earth's crust, while rock is its most compact form. Big Corona in Newport Beach combines a wide sand beach bordered by distinctive rock groupings. Orange County beaches range from rocky, rugged sections to flat sandy strands. (Courtesy OC Archives.)

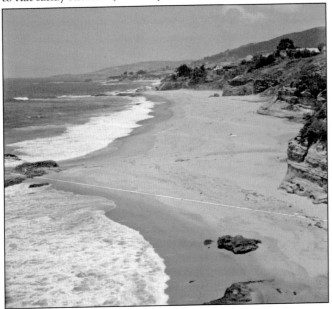

**TREASURE ISLAND, CAMEL POINT.** Sand particles along the coast are perpetually pushed by wind, waves, and currents, gradually building into sandbars, dunes, and beaches. This wide sandy strand at Laguna Beach speaks for itself. That city may have the greatest number of local city beaches in California. (Courtesy OC Archives.)

**Salt Creek Beach.** Orange County's coast enjoys great surfing waves because of its lengthy western-facing beaches. Salt Creek Beach in Dana Point also has a small offshore reef that adds to the challenge of surfing. This beach is hidden from the highway, requiring a hike and stairs to reach it, but surfers and sunbathers agree it is worth the effort. Its next-door neighbor is the Ritz-Carlton Resort. (Author's collection.)

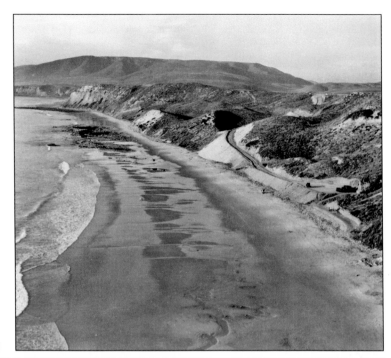

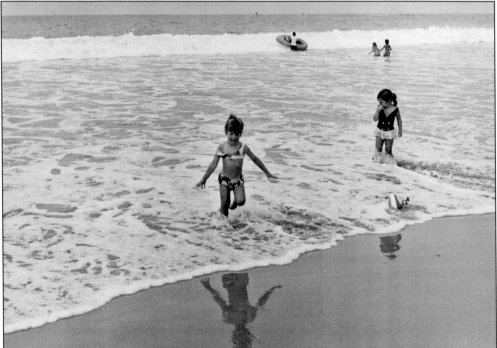

**Sand and Water Mix.** Youngsters playing in near-shore surf learn their first lesson in oceanography. The lass at left enjoys the incoming water, knowing she is still on firm sand, even on one foot. The girl at right studies the moving water quizzically, analyzing its action while keeping both feet firm. Older children brave the next incoming wave with the security of an inflated boat or a buddy's hand. (Author's collection.)

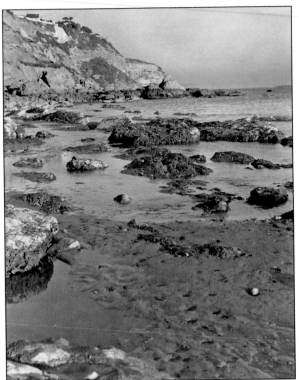

**TIDE-POOL SEA LIFE.** Tide pools are shallow pockets that trap water and oxygen at each high tide. They are most visible on rocky beaches from Newport Beach south. Sea life within them is protected by law against touching or taking, but they can be admired with eyes and cameras. The image at left is a 1960s view, taken at lowering tide in Dana Cove. The scene below is the same spot in 1969 when Dana Point Harbor was being created. After the boating basin was coffer-dammed and pumped dry, sea creatures never before out of water were exposed in these artificial tide pools. Marine science students prowled through the mud to search out and save specimens that would have died. They inventoried the species, then turned them over to divers to be placed safely outside the harbor. (Photographs by the author.)

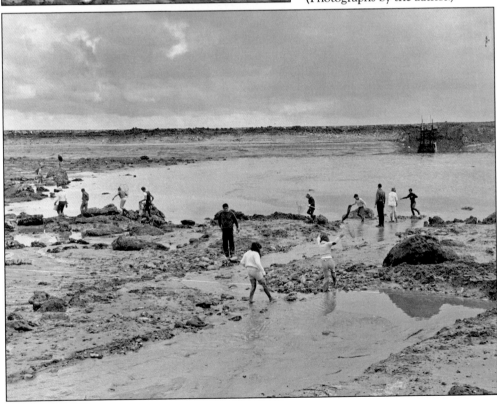

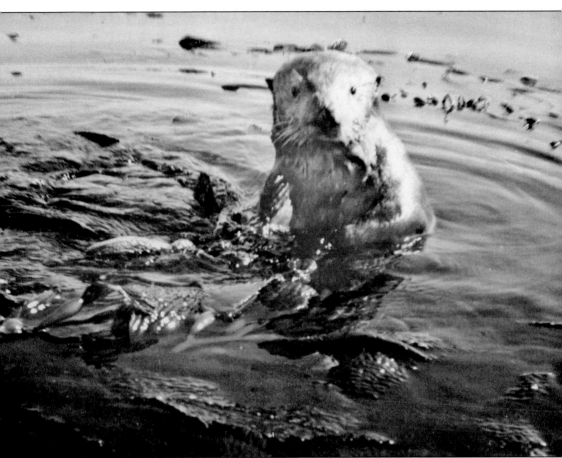

**WORLD'S LARGEST FOREST.** Off the Orange County shore grows the largest forest on earth—giant kelp or seaweed. It provides a home for schools of fish, therefore also attracting fishing birds. Replanting a spent kelp bed is a scientific challenge. A deep artificial reef off San Clemente has been planted recently. The kelp forest that grows from that rock reef could eventually create a canopy covering 150 acres, housing 50 tons of fish. The kelp off the local coast once also housed a major population of sea otters. While they slept above, they were known to anchor themselves to secure strands of seaweed. Mother otters thus tethered their young while they hunted for food below. Otters were slaughtered to extinction here in the early 1800s for their very dense fur. Healthy kelp helps the surf from breaking too hard against the rocks. When it was severely cut away for potash processing during World War I, the breakers came onshore harder and surfing conditions heightened. (Photograph by the author.)

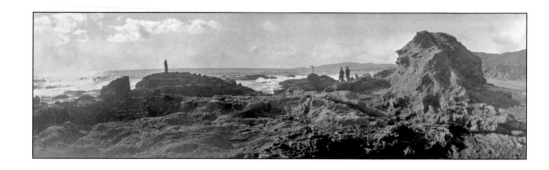

LAGUNA BEACH ROCKS. Some are smooth and circular from constant rolling in the moving tides. Some are dramatically irregular and secured in place. Some are massive and defy the turmoil of the ocean and the sand. The shore of Laguna Beach includes unusual, decorative, and popular rockwork. Rockpile Beach, above, is just what it says. Piles of rock evade the reach of the sea at high tide. Many large boulders lying along the beach have broken away from the marine terraces above since they were uplifted with cataclysmic force in prehistoric times. Laguna's Table Rock is shown below. Pieces of rock still break away from time to time as erosive wind and rain weaken the cliffs; gravity pulls the loosened sections to the beach. (Above, courtesy Anaheim Public Library; below, courtesy OC Parks.)

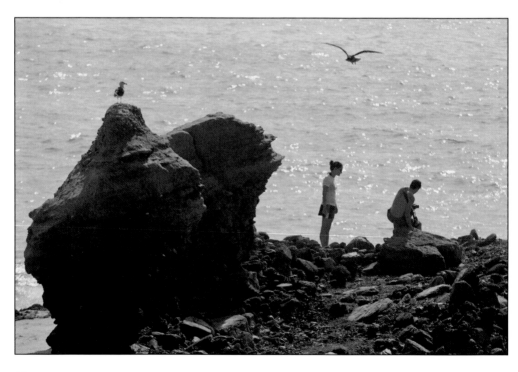

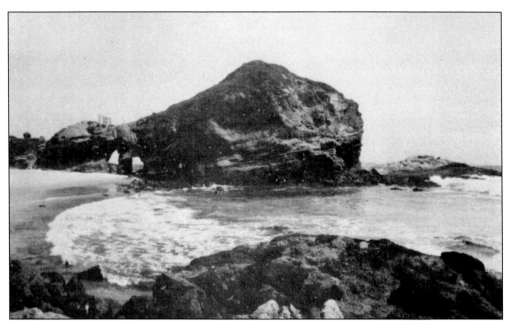

**THREE ARCH BAY.** The sea has carved some of the Orange County coast into cliffs, coves, caves, and arches. Three Arch Bay's beach reveals three places where the sea over time has punctured the rock to work its way inside the bay. It takes two early photographs to show all three of the arches, which have always been a popular backdrop for keepsake seaside photographs. Each arch is more than 6 feet tall and 4 or more feet in width. The scenery changes from one side to the other of these natural portals—beach strand on one, rocky tide pools on the other. Whale Island at Three Arch Bay is named for its shape, looking like a migrating gray whale. (Both author's collection.)

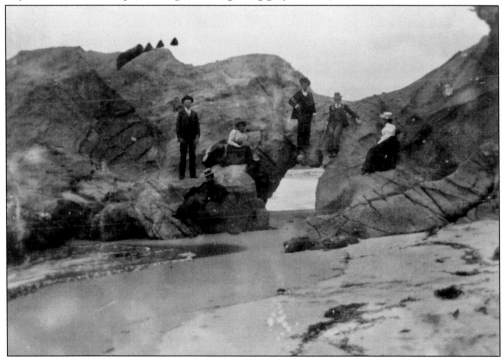

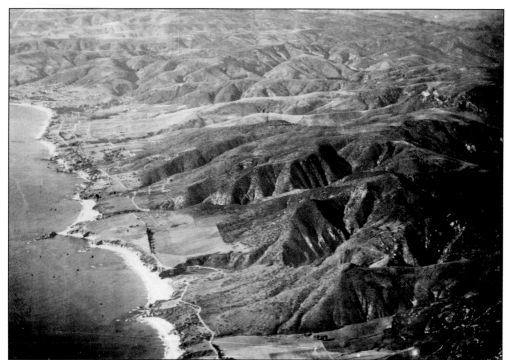

THE CURVE OF COVES. A cove is a circular or oval inlet where rock or sand is weaker than that surrounding it and washes away over time. The above aerial photograph was taken when South Laguna was yet undeveloped. The early coastal road is visible, as is the earlier downtown settlement at upper far left. Each cove generally holds a sandy beach (below), the fingers of rock around it protecting it from onshore winds. The Orange County coast ranges from sea-level beaches to marine terraces ending in sea cliffs up to 200 feet high and flat coastal stretches to headlands and points that jet out into the ocean. (Both author's collection.)

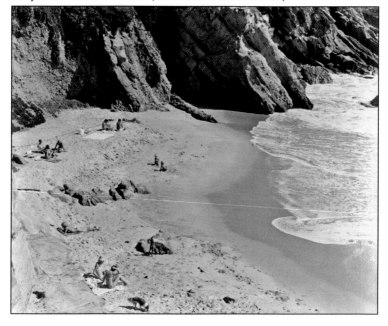

**CELEBRATED DANA CLIFFS.** The cliffs that frame Dana Point Harbor represent the unusual coming together of three marine sedimentary bedrock formations. The buff-colored cliffs of the Capistrano Formation show the pleasant erosion of the ages from the south entrance up to Cove Road, beyond which the headlands display the oldest, least erosive San Onofre Breccia. North of the headlands lies the grayer Monterey Formation beginning at Dana Strand. (Photograph by the author.)

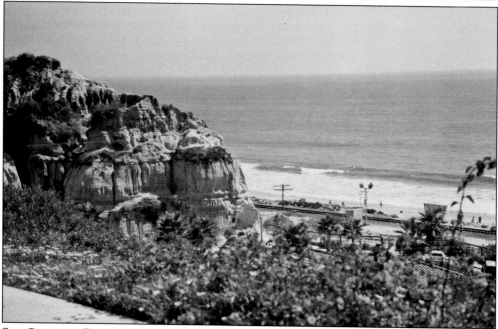

**SAN CLEMENTE BADLANDS.** Erosion of Capistrano bedrock in south San Clemente over eons has formed monumental bluffs hinting at the Dakota Badlands. Their various strata are easily visible. The best view of these cliffs is aboard the Amtrak Surfliner train, where they vie with the beach and ocean scene passing close by across the aisle. There is also a trail at the cliffs' base within San Clemente State Beach. (Photograph by the author.)

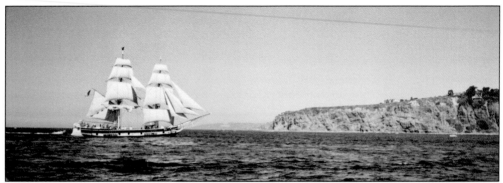

ONLY NATURAL ANCHORAGE. Orange County's only natural anchorage was at Dana Point—the offshore waters so shallow and rocky that early trading ships anchored far offshore. That coastal cove fulfilled its destiny as a safe harbor in 1971. Seen approaching the headlands, a natural navigational landmark, is the *Pilgrim* that docks at the Ocean Institute there. It is a re-creation of the ship that brought namesake Dana on his 1835 visit. (Photograph by the author.)

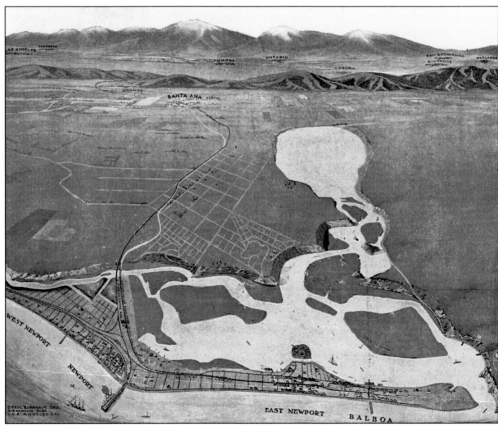

UPPER NEWPORT BAY. This 1910 drawing of coastal Newport Beach shows the dramatic octopus shape of the Upper (or Back) Bay. It contains about 1,000 acres of natural estuary, where fresh and salt water mix—one of only a few remaining in Southern California. It is home to nearly 200 species of birds, including several endangered ones. The Upper Bay is also an important resting place for birds migrating along the Pacific Flyway. (Courtesy OC Archives.)

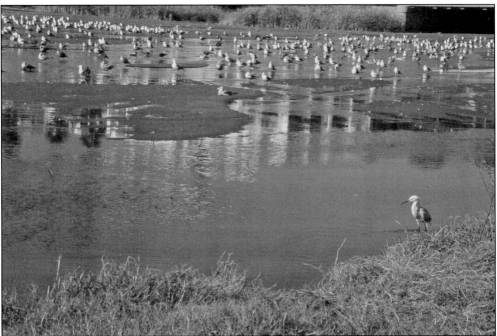

**NEWPORT NATURE PRESERVE.**
Today the inland bluffs are
part of Upper Newport Nature
Preserve and Ecological Reserve,
including both grasslands and
coastal sage scrub communities.
Thousands of birds a day visit
during winter. This reserve was
established in 1975, including
acreage from the Irvine ranch
and tidal wetlands. The county
created a 140-acre regional park
(pictured here) and maintains
the distinctive Muth Nature
Center in Upper Newport Bay.
Wild birds seek sanctuary there
(above). A lone egret looks
across the channel at the major
gathering of shorebirds enjoying
this winter haven. Tidal islands
form as the ocean knocks on
the Back Bay's entrance and
rushes in and out. The ecological
reserve totals 752 acres including
wetlands. Right, a lone hiker
becomes one with the park
scene. (Above photograph by the
author; right courtesy OC Parks.)

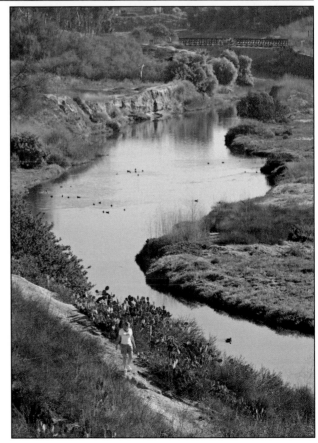

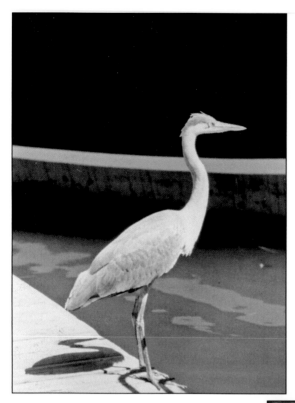

**SHADOWS OF THEIR PAST.** The great blue heron is one of two coastal birds drawing attention for their beauty, size, and feeding habits. Both live in shadows of their former populations. Herons nest and raise young on platforms they build in tall trees. They stand in shallow seawater, then suddenly plunge their heads down to grab fish. This "species of concern" could be on its way to endangerment. (Photograph by the author.)

**BROWN PELICANS' PLIGHT.** These large fishing birds are a success story that may lack a happy ending. Pelicans were severely endangered when DDT prevailed in their waters, thinning their eggshells. Other factors caused disabilities and deaths. They have come back, but full survival depends on the quality of their water habitat—in the shadow of their past. They fly over water, then dive directly downward to make a catch. (Photograph by the author.)

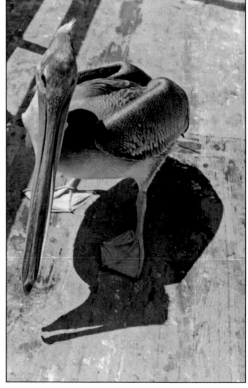

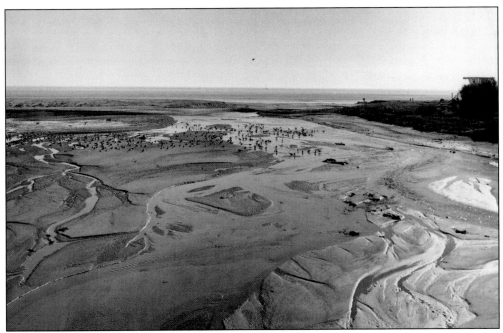

**DOHENY STATE BEACH.** San Juan Creek reaches the ocean within Doheny State Beach. The silt that collects at its mouth creates seasonal mudflats for shorebirds and migratory species. The park's beach and campground lie to the south of the creek, while Dana Point Harbor begins at the north. Doheny's campground has long been the most popular in the state's coastal system. (Photograph by the author.)

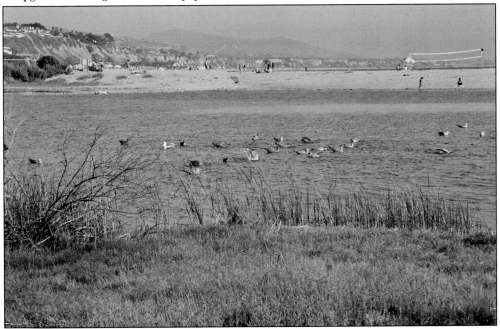

**DOHENY PARK GOERS.** This popular camping site at the mouth of San Juan Creek in Dana Point has something for everyone. In the upper level of this image, the wide beach and saltwater are enjoyed by swimmers, sunbathers, and volleyball athletes. The flow of freshwater into the sea (center) attracts ducks, geese, and shorebirds with a grassy foreground enabling them to dry off in the sun. (Photograph by the author.)

23

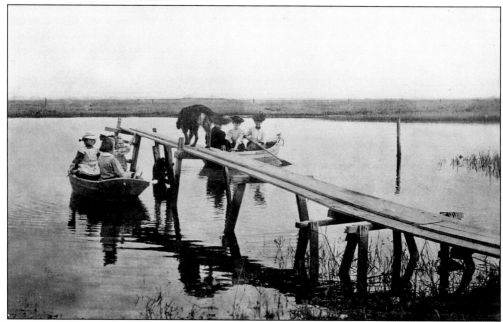

**BUSY SEA EXTENSION.** The urge to walk over water into the ocean has been fulfilled over and over along this county's coast, which now has numerous piers sturdier than this one. Simply built, the early extension of the shore at Sunset Beach was photographed in 1911. It served swimmers, fishermen, and boaters of all ages and sexes, even challenging this dog to play pirate by walking its narrow plank. (Courtesy First American Corporation.)

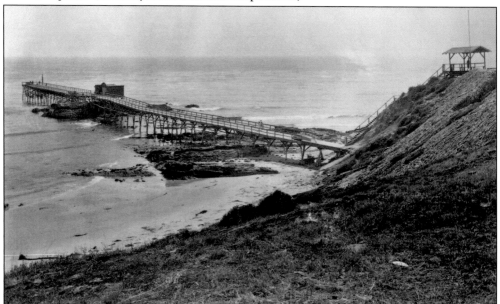

**LAGUNA'S EARLY PIERS.** Laguna Beach had two ocean piers before 1900. A pleasure pier built at Heisler Park was reached by challenging stairs. Another at Wood's Cove Point extended only to the first large offshore rock, into which iron rings were inserted. This enabled schooners to be landed by tackle system, so lumber could be unloaded and farm goods shipped out. Both piers were done in by ocean wave action. (Author's collection.)

**BEACH CLUB EROSION.** The luckless Capistrano Beach Club was built by Edward Doheny Jr. as a focal point of his stylish 1920s shore and palisades development. Through depression, war, and years of neglect, it was left to hold its own ground with the stormy sea. Erosion finally took its untended beach, and would-be developers took apart its classic architecture in the 1960s. The property became Capistrano Beach Park. (Photograph by the author.)

**JETTY ROGUE WAVE.** Killer Dana died with Dana Point Harbor, but its spirit sent a set of 20-foot breakers to smash over the new east breakwater in 1968. Twenty-five fishermen and hikers atop it were swept into chilly water. The two victims visible here, stranded on the jetty, were rescued by a passing private plane. Only injuries occurred, and such a rogue wave has not been seen again. (Courtesy OC Sheriff's Harbor Patrol.)

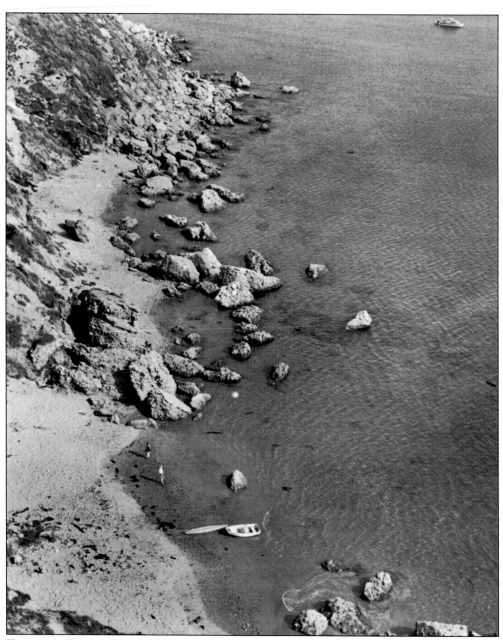

**TEMPORARY POCKET BEACHES.** These "now-you-see-them, now-you-don't" short stretches of sand or rock appear, then disappear, by the will of the tides. They even provide temporary landing spots for small boats, until the tide rolls in again. These narrow strands are protected from prevailing offshore breezes by the vertical cliffs. The pictured pocket beach at pre-harbor Dana Point was described in namesake Richard Henry Dana's 1840 book, *Two Years Before the Mast*. He wrote that it was the only landing place for the longboats that brought sailors to this shore to trade goods for cattle hides. Trading appointments had to coincide with lower tides to assure them of a landing place. Except for the fill earth added to reinforce the base of the cliffs when Dana Point Harbor was constructed in the late 1960s, the Capistrano Formation bluffs look much as they did when Dana viewed them. (Photograph by the author.)

# *Two*

# WINDING WATERWAYS

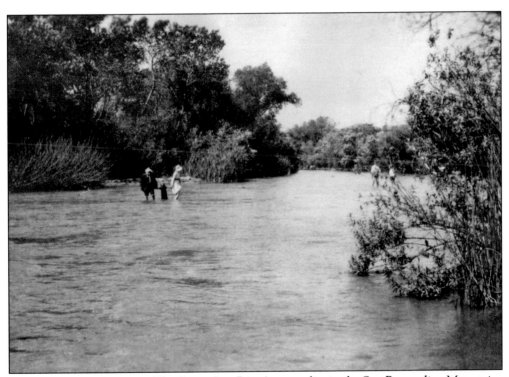

**COUNTY'S LIQUID LIFELINE.** The Santa Ana River's source lies in the San Bernardino Mountains 110 miles from the seacoast, which it reaches between Newport Beach and Huntington Beach. This 1890s photograph shows the river at a high level in Santa Ana Canyon, probably a spur-of-the-moment act by these rugged, well-dressed waders. The surrounding trees bow to the strength of this county's lifeline river. (Courtesy Anaheim Public Library.)

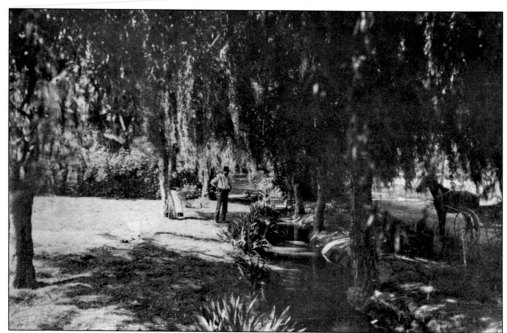

**HARNESSING NATURE.** Before the eras of pipelines and reservoirs, the German settlers of Anaheim in 1857 wisely planted their grape-growing/wine-making colony by the major water source, the Santa Ana River. Spanish explorers had named it, so the Germans called their colony Anaheim—"home by the Ana River." Its water was diverted into irrigation ditches like this tree-lined one. (Courtesy Anaheim Public Library.)

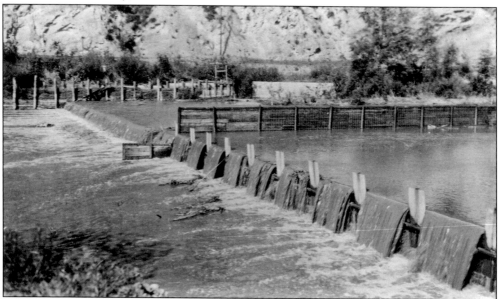

**CAJON CANAL GATES.** Anaheim Water Company became California's first organized irrigation agency in 1859. Diversion ditches and flumes carried water to more than 2,000 acres of vineyards. In 1884, it became the Anaheim Union Water Company, including Cajon Irrigation Company. Here the Santa Ana River flows through the headgates of the Cajon Canal in Bedrock Canyon. This 1890 photograph shows the diversion dam and filtration system. (Courtesy Anaheim Public Library.)

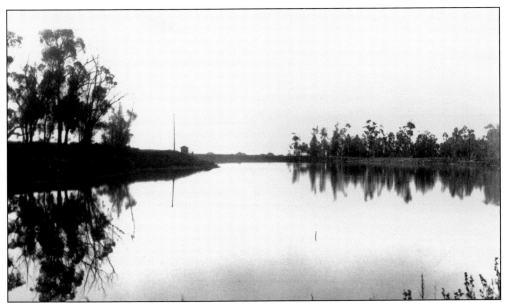

EARLY TUFFREE RESERVOIR. The Anaheim Union Canal was completed in 1879. It ran 10 miles from Santa Ana Canyon along the foothills to Tuffree Reservoir, built in 1910, date of this image. Now located in Tri-City Park, the former reservoir—like many in the county—is a park amenity. That site is jointly managed by the Cities of Brea, Placentia, and Fullerton. (Courtesy Anaheim Public Library.)

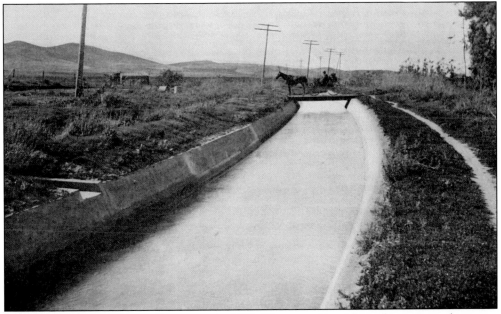

VALLEY IRRIGATION CANAL. Beginning in 1871, Chapman Canal brought water to the towns of Olive and Orange. Later farmers in Tustin and Santa Ana joined those two to form Santa Ana Valley Irrigation Company, drawing water from the Santa Ana River. One SAVI irrigation canal provided both water and power to the historic 1882 Olive Flour Mill, the main valley industry. "Horsepower" had a presence on the main canal in this 1913 image. (Courtesy Anaheim Public Library.)

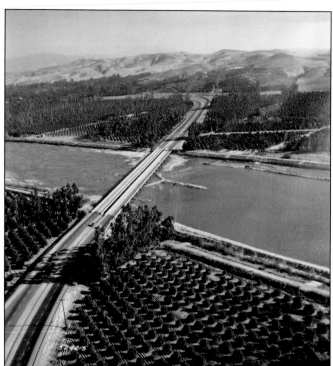

**A RIVER RUNS BY IT.** Today's Santa Ana River is crossed by several freeways and many bridges. The river received this bridge in 1956 when the Riverside Freeway was constructed. In this aerial photograph, looking east toward Santa Ana Canyon, orange groves still covered both banks of the river. Cities lying along the Santa Ana River are pursuing plans to enhance the river's banks with parks and trails. (Courtesy Caltrans.)

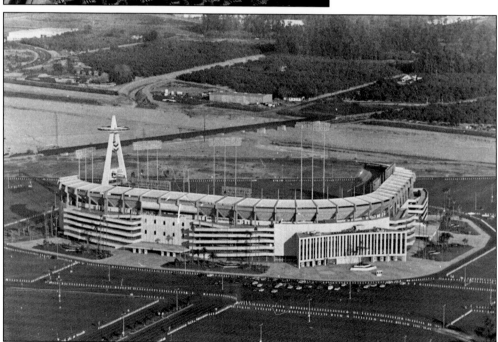

**"BIG A" BY THE ANA.** This 1970 aerial view shows Anaheim Stadium across the Santa Ana River from historic citrus orchards. Its 23-story Big A sign stands within the sports park but was moved closer to the river in 1998. The stadium's outfield victory display features a geyser shooting water 90 feet high to form an artificial "stream," fed by a 30,000-gallon tank. (Courtesy Anaheim Public Library.)

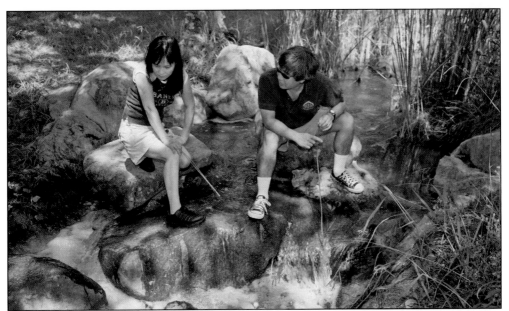

**RIVERFRONT AMENITIES.** The Santa Ana River flows beside county landmarks like historic Yorba Regional Park, once part of a rancho. It is a linear facility, designed to recapture the original river setting along its 1.5-mile length. Park visitors (above) dabble in one of the streams connecting its series of lakes. Anaheim Coves, a city environmental development, is planned along 6 miles of its riverfront. (Courtesy OC Parks.)

**SERRANO CREEK.** This tributary flows from Santiago Canyon Road within Limestone Canyon/ Whiting Ranch Wilderness Park and on through the more urban landscape of the Saddleback Valley, visible in the background of this 1976 image. Some of the trails within that park describe the ascending terrain well: Live Oak Trail, Cactus Hill, Billy Goat Trail, Dreaded Hill Road, Upper Pond Trail, and Vista Lookout. (Courtesy OC Archives.)

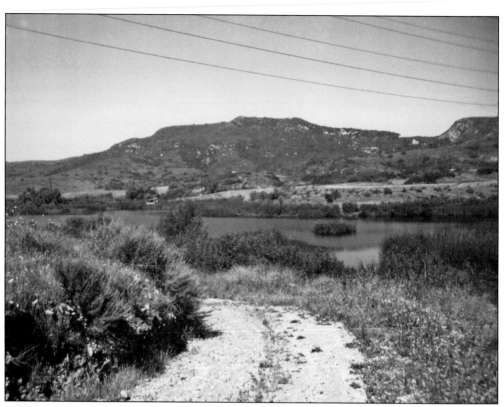

**NATURAL LAKES.** Orange County has three natural lakes, together in Laguna Canyon within a restored natural habitat. The first dries up in summer. The second, now a habitat for reptiles and amphibians, is Bubbles' Pond, named for the hippopotamus that escaped Lion Country Safari in 1978, living in this lake until she died in a rescue attempt. The third, the largest at 12 acres, is Barbara's Lake, named for local environmentalist Barbara Stuart. (Courtesy OC Archives.)

**HISTORIC IRVINE LAKE.** This man-made reservoir was a 1930s antidote to drought within Orange County's first park, now Irvine Regional. It was at first filled from underground springs within an old marsh. Santiago Reservoir now holds back reserve water. Boating and fishing are popular, and trails lead through native landscape. The movie *Lassie Come Home* was filmed in this park in 1943. (Courtesy First American Corporation.)

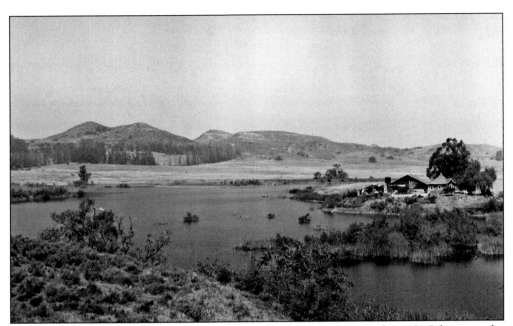

**PETERS CANYON RESERVOIR.** This 55-acre lake in Orange was constructed in 1931. It has its outlet in Peters Canyon Creek, a tributary of San Diego Creek, second largest county watershed. Since this photograph, the lake became the focal point of Peters Canyon Regional Park, which winds within the canyon amid willows, riparian landscape, and natural wetlands surrounded by foothills. One trail is named for the endangered gnatcatcher bird. (Courtesy OC Archives.)

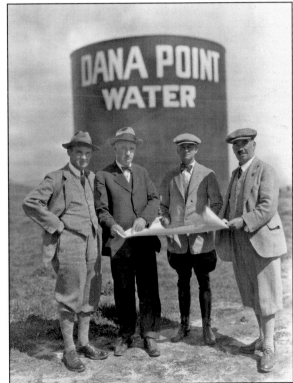

**WATER OR AIR?** Early developers in south Orange County had to rely on the erratic flow of seasonal native creeks and unreliable wells for water. Tank "reservoirs," like this one that Dana Point builders erected in the 1920s, were more billboards aimed at reassuring lot purchasers that there was an ample on-site water supply— decades before an imported source was introduced. Was it really filled with water? (Author's collection.)

33

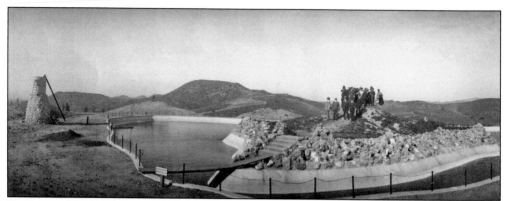

**ELEVATING NEEDED WATER.** When citrus growing became a major industry in Orange County in the early 1900s, the irrigation needs were overwhelming. As valleys filled with groves, new highs were reached with creation of tracts in Lemon Heights above Tustin. In those days before aqueducts or imported water, the only water source was local wells in the valley. During the 1910s, this elaborate hilltop reservoir solved that problem. Water was pumped electrically through steel pipes to the top, then distributed to groves by gravity flow. Later deeds included Lemon Heights Water Company shares. Tustin citrus growers included C. E. Utt (Utt Juice Company) and Dr. Willetta Waffle (Orange County's pioneer female doctor). Historian Samuel Armour wrote, "A fine view of the valleys and plains . . . may be had from these heights; and doubtless many palatial residences will be erected there in the near future, whose occupants may thus perennially enjoy the beauties of nature enhanced by the arts of civilization." (Courtesy Anaheim Public Library.)

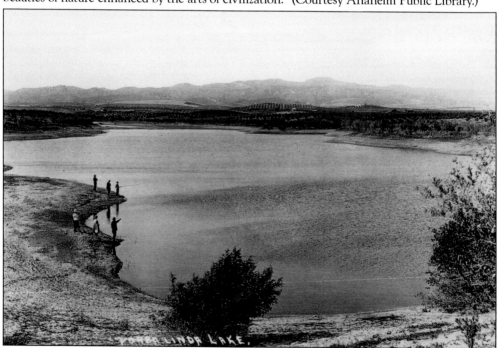

**EQUESTRIAN LINKS.** Anaheim Union Water Company built a narrow-gauge railway to haul dirt for this 1907 dam, which captured river water for citrus grove irrigation. When that crop diminished, it became a recreational lake. Residents of Yorba Linda even swam their horses there. Its draining in 1969 created Yorba Linda Lakebed Park. Now it is the proposed site of an equestrian center, this time with stables, show ring, and bridle trails. (Courtesy First American Corporation.)

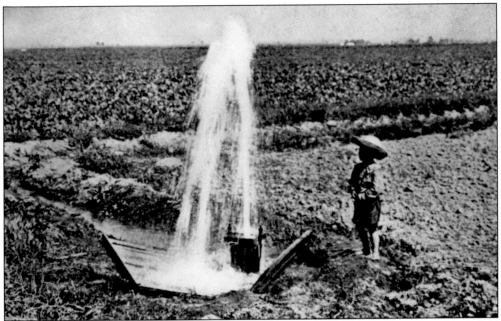

**ARTESIAN WATER.** Natural underground water was plentiful in parts of Orange County. Here a child stands in awe of an early artesian water gusher in Fountain Valley, named for such spontaneous field fountains. It was even said that in many places, whenever a hole was dug, water gushed forth. Some early communities depended on it for fresh water. When drained with canals, the reclaimed land below was rich for agriculture. (Courtesy First American Corporation.)

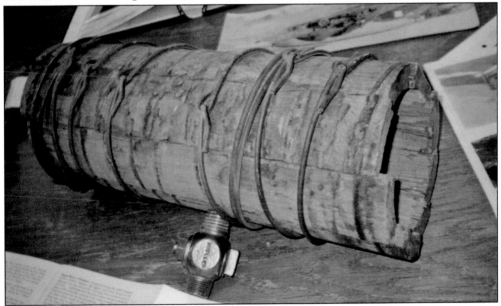

**EARLY WATER PIPE.** When water was transported underground in the early 1900s, it was carried in sturdy wire-wrapped redwood pipes. The section pictured is now a historic relic of the Laguna Beach Water District, which replaced miles of such pipes through the years, as have most early water agencies. Figuratively speaking, what can carry water more successfully along lengthy—even uphill—stretches than a tall redwood tree? (Photograph by the author.)

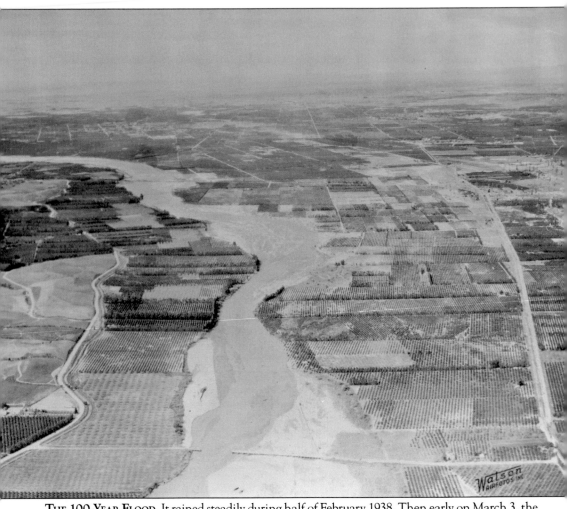

**THE 100-YEAR FLOOD.** It rained steadily during half of February 1938. Then early on March 3, the Santa Ana River jumped its banks at the Yorba Bridge. A levee gave way, opening a new branch of the river. The 8-foot wall of water it created tore through small communities, which suffered the greatest loss of life. The deadly water reached Anaheim within an hour and continued on. As it spread north, the flood wave became a wall of dangerous debris. Another levee broke, becoming another branch of the river. The flood eventually reached Newport and Seal Beach, until nearly the entire county was a lake. Evacuees lucky enough to have a boat, it is said, could row it from Santa Ana to the coast. Bridges were damaged or destroyed. This aerial photograph was taken a week later, with floodwaters somewhat receded. Anaheim is at upper left and center. This 100-year flood was Orange County's worst natural disaster. Three years later, earthen Prado Dam was completed just east of Orange County to catch the river's flow. (Courtesy OC Archives.)

**COYOTE CREEK.** This natural divide has controlled the northwest corner boundary between Orange and Los Angeles Counties since they separated in 1889. Shifts in its flow have changed those borders over that century-plus. Coyote Creek eventually empties into the San Gabriel River. Here in 1958, at Lambert Road in La Habra, the creek bed was still an urban wilderness for adventurers. (Courtesy OC Archives.)

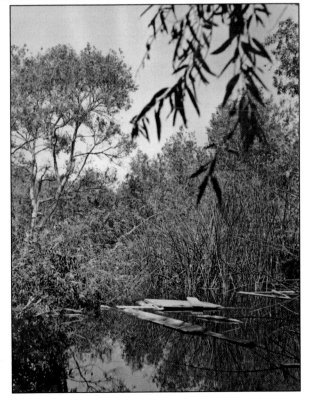

**LAST PEAT BOG.** This was Orange County's last natural peat bog, west of Brookhurst Road in Huntington Beach. Bogs are muddy because they contain much decayed plant humus and a very shallow water table. Some plants can thrive within this rich earthy element. The coastal Orange County bogs, drained during the 1870s, became rich nutrient-filled land for agriculture. (Courtesy OC Archives.)

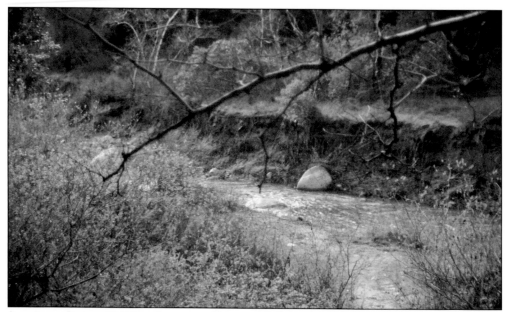

**SAN JUAN CREEK.** Visible only as a trickle as it leaves its source in the Santa Ana Mountains within Cleveland National Forest during a dry season, San Juan Creek was the original focal point of Spanish settlement at Mission San Juan Capistrano. Then when insufficient water for agricultural irrigation proved a problem, the mission site was moved to the confluence of that waterway and Trabuco Creek. However, when replacement water from the clouds inundates its channels, gentle San Juan Creek can become a fast-rushing stream. It kicks up to rapidly flowing white water. A green landscape springs up quickly along its banks. The San Juan Creek watershed covers 134 square miles of the south county. This creek's tributaries include Arroyo Trabuco and Oso Creek. (Photographs by the author.)

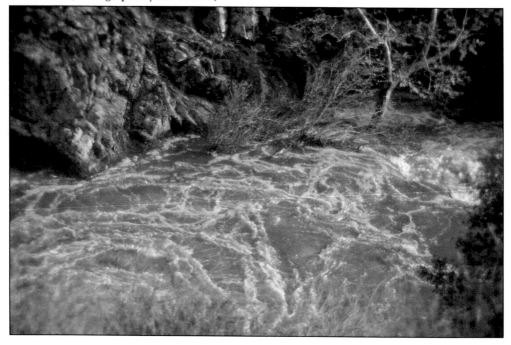

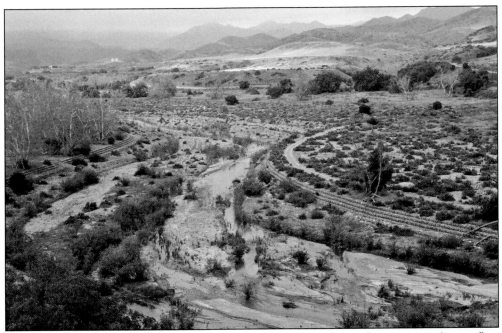

**SEASONS OF EROSION.** San Juan Creek reveals its eroding banks during drier seasons when its flow is reduced. Then it shows the cumulative action of nature during earlier seasons when rushing water cascaded along its earthen channel through the inland Capistrano Valley. In drier seasons, it pokes along at a rather level but rambling, desert-like path, slowed by some obstinate plants that root themselves in its sandy bottom. (Photograph by the author.)

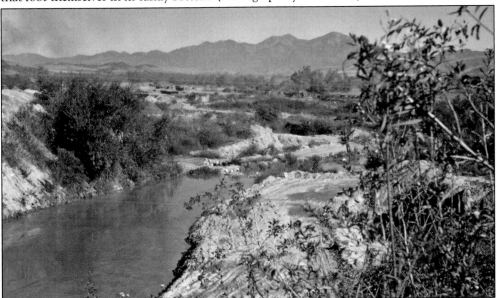

**SCENIC BANK SPOILAGE.** A postcard scene of San Juan Creek off Ortega Highway in 1960 includes mountains, valley, and flourishing plant life. Here is also evidence of a sand and gravel operation beside the creek. The flow of creeks over time deposits sediments that enable the extraction of quality sand and gravel from otherwise unmolested creek beds throughout Orange County. Sand and gravel is California's leading industrial mineral. (Courtesy OC Archives.)

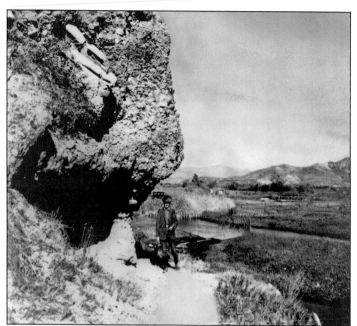

**CREEK CROSSES VALLEY.** San Juan Creek once flowed freely through the agricultural fields of surrounding Capistrano Valley, its riverbed revealing a sandy, rocky bottom. The growth of tules, visible in this early-1900s image, furnished reeds for Native American huts; its fish included wild trout. Here a visitor poses beside the creek beneath a rock outcropping characteristic of the south county coast. That large rock has since fallen away. (Author's collection.)

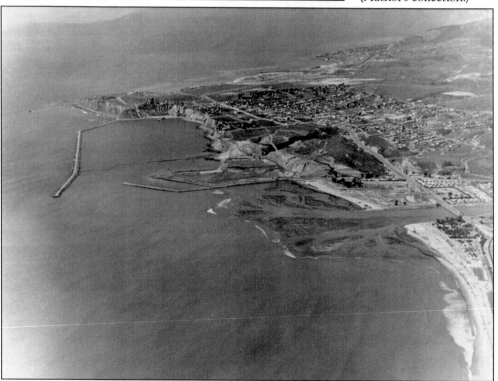

**OUT TO SEA.** San Juan Creek ends in Dana Point, its banks now lined with concrete below a pedestrian-bike trail. When its waters reach the sea at Doheny State Beach during stormy weather, they carry silt from inland areas, seen in this photograph taken during a 1969 flood when heavy rains soaked the entire county. Then this creek also carried orange trees onto the beach and out to sea. (Author's collection.)

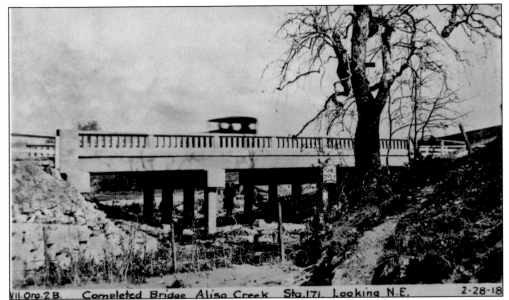

Vll.Org.2B.    Completed Bridge  Aliso Creek   Sta.171  Looking N.E.              2-28-18

**ALISO CREEK.** The above scene snapped in 1918 celebrates completion of a bridge over Aliso Creek near the coast. The image was taken by the county road department in February, when the creek bed appears to be dry and the adjoining tree has shed its leaves, maybe signifying a drought season. Below, Aliso Creek reaches the ocean at Laguna Beach. Here a simple bridge crosses what would become Pacific Coast Highway in the 1920s. Today it is the site of an inn, golf course, and proposed resort across from Aliso Beach. The Aliso Creek watershed covers more than 30 square miles. Its tributary originates in the Santa Ana Mountains inside Cleveland National Forest. Its smaller tributaries include Wood Canyon and Sulphur Creek, Aliso Hills Channel, and English Channel. (Both author's collection.)

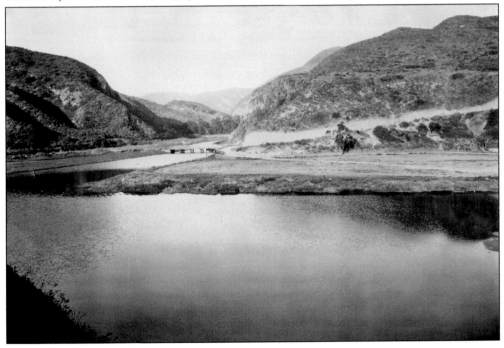

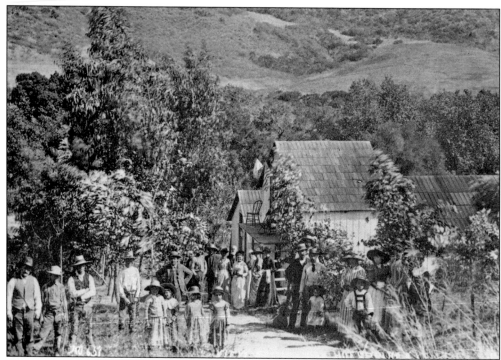

HISTORIC HOT SPRINGS. During the 1890s, San Juan Hot Springs was a popular tourist attraction. This natural flow of hot water led to construction of wooden tubs, rented by the hour for heated soaks. Ladies camped in long dresses and sun hats, men in vests and ties. The main building offered a rooftop viewing chair for the daring, as the above photograph proves. This resort included a dance hall—a historic structure moved to the Capistrano City Hall complex—and a pavilion among a dozen buildings. The temperature of natural flowing water from Hot Springs Canyon was as warm as 122 degrees. Dipping in the hot pool was still an attraction into the days when swimming required less formal attire (below). There was always a proverbial lad who dared dunking by balancing on a narrow wall. (Both author's collection.)

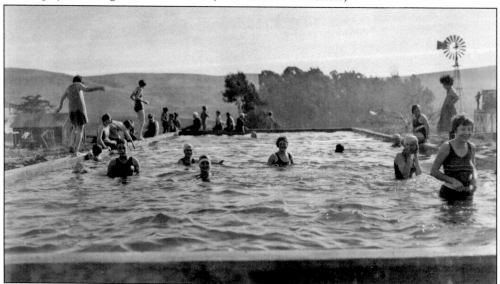

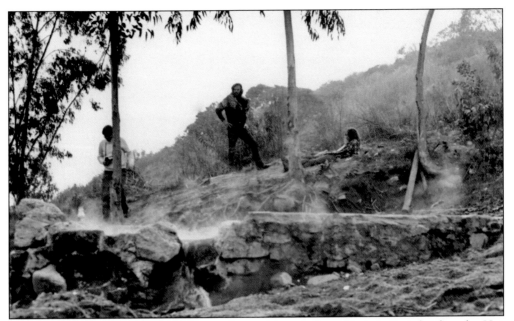

AGING HOT SPRINGS. Train travelers took a stagecoach from Capistrano inland to the Hot Springs, which eventually became part of Caspers Wilderness Park in the 1970s. The redwood rental tubs and trailer hookups lasted a while longer. There were often photograph buffs ready to record the aging, steaming tubs, rock walls, and lingerers. The tubs were covered in recent years, the grounds wired shut. However, San Juan Hot Springs lives on the National Register of Historic Places. (Photograph by the author.)

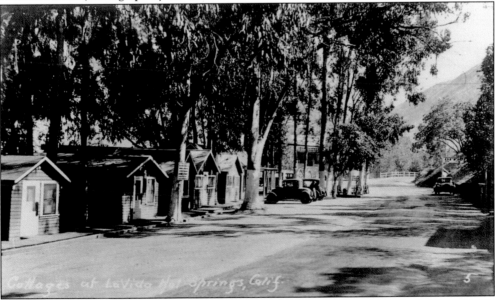

LA VIDA HOT SPRINGS. This was north Orange County's hot water resort in the 1930s, a health spa in Brea's foothills. About 30,000 gallons of water a day, at up to 110 degrees, flowed through. It featured hot tubs, spa, cabins, modest hotel, café, and live bands. Some of the water was flavored and bottled as Lime N' Lemon Soda. By the 1970s, it faded into a roadhouse, flavored with rock bands and motorcyclists. (Courtesy First American Corporation.)

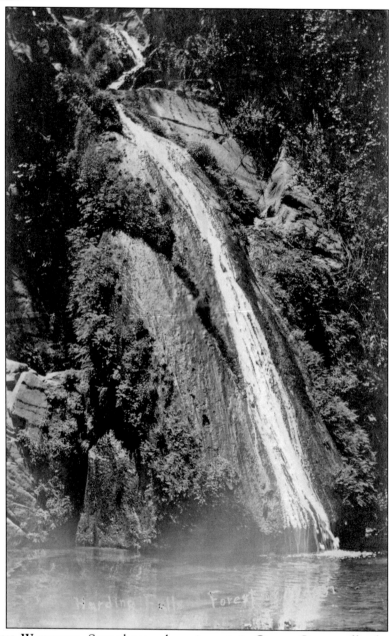

**A SEASONAL WATERFALL.** Several natural scenic spots in Orange County offer the charming surprise of a seasonally flowing waterfall—usually in or after rainy weather. This one was first named for Samuel Shrewsbury, early Silverado Canyon landowner. This waterfall was one of the special amenities on his property. It became known as Arden Falls when the property was purchased by famous Polish actress Helena Modjeska. She and her husband, Charles Bozenta Chlapowski, chose this site in Santiago Canyon to build their dream ranch. Modjeska named it Arden for the Forest of Arden, a setting in one of this Shakespearean actress's favorite plays, *As You Like It*. More of the Modjeska ranch's scenery appears in the "Rustic Canyons" chapter. Other county waterfalls occur in Holy Jim Canyon and Laguna Canyon Wilderness Park. (Courtesy OC Archives.)

# *Three*

# BACKDROP MOUNTAINS

**OLD SADDLEBACK MOUNTAIN.** To Orange County residents, "the Mountain" has an endearing name—Old Saddleback, referring to its shape like a saddle. This standout of the Santa Ana Mountains has two peaks—both more than a mile high. The taller is Santiago Peak, the name meaning St. James in Spanish. The lesser by 191 feet is Modjeska Peak, named for famous Polish actress Helena Modjeska, who lived near its base. (Courtesy OC Archives.)

**MOUNTAINS ADD MAJESTY.** Mountains delineate Orange County's eastern border. This scenic study in light and shadows within today's Santa Anas reveals the pleasing patterns along the dramatic slopes. Is a future canyon forming here? Native chaparral, the carpet of the Old West, still covers much of this dramatically jagged scenery. (Photograph by the author.)

**RUTTED RUSTIC ROADS.** The Santa Anas form the eastern backdrop of Orange County's landscape. Even by the 1950s, entries into the local foothills were unpaved two-rut roads like this. The standout firebreaks had been lengthened and widened. Rough brush grew heavily along the roads, encouraged by rainy weather. When rain was replaced by Santa Ana winds from the canyons, fire alerts were sounded throughout the inland areas. (Courtesy OC Archives.)

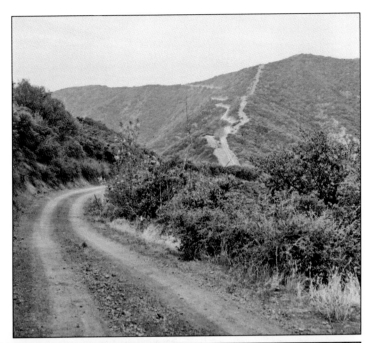

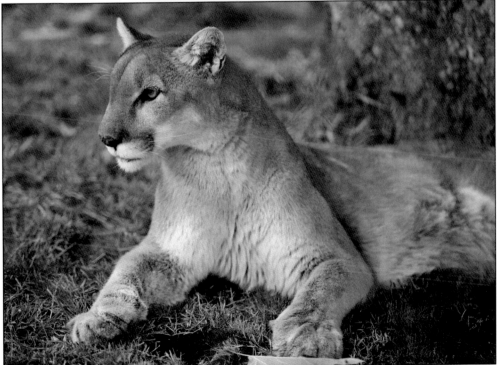

**KING MOUNTAIN LION.** Named for the terrain it favors, the mountain lion or cougar has come back from near extinction to a "protected" species. Ever on the hunt, these solitary nocturnal carnivores each require a territory up to 100 square miles. Powerful and elusive, they can leap down from a tree or cliff to surprise unwary prey. This handsome specimen is a resident of the Orange County Zoo, which features local native animals. (Courtesy OC Parks.)

**LORD OF THE LAND.** The early Native Americans who lived in Orange County believed that their god, Chiningchinish, resided on Santiago Peak of Saddleback Mountain, which they called Kalawpa, meaning "wooded place." In this photograph, that sacred spot seems to be the source of ethereal clouds floating out of and over the mountain range. On the Riverside County side, it is known as Temescal Mountain and was once called Mount Downey. (Courtesy OC Archives.)

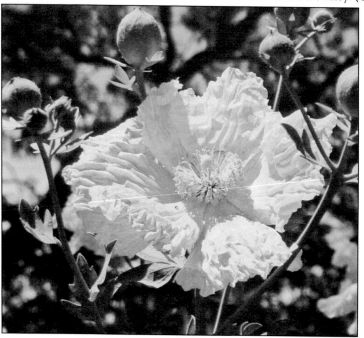

**WHITE MOUNTAIN POPPY.** While golden California poppies are the treasure of spring fields throughout the state, this Matilija poppy is known as the queen of its wildflowers. Its stems, up to 8 feet tall, lift it above its surroundings in mountains and canyons. The Matilija's leaves are small, but its very large, white, crinkled, fragrant blooms are what make it a standout sight at altitudes up to 4,000 feet. (Photograph by the author.)

**Spanish Sight Saddleback.** The first European explorers to enter Orange County in 1769 stopped in San Juan Canyon, where they camped in sight of Old Saddleback. On this medallion struck for the 200th anniversary of their expedition, the master mountain is the focal point of the scene. The scout pointing it out is Jose Ortega, for whom the highway leading to the mountain from the south is named. (Author's collection.)

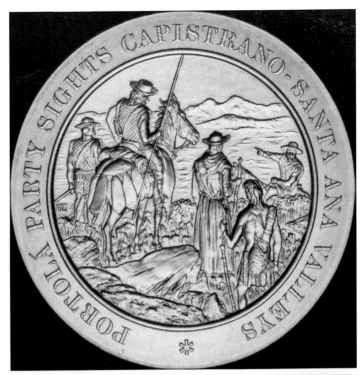

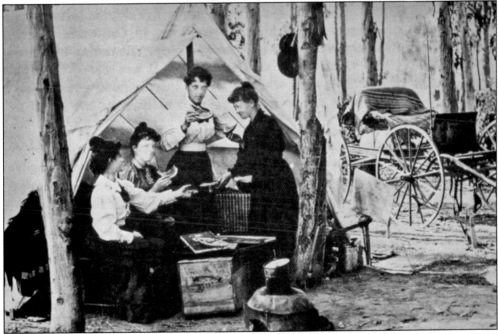

**Genteel Mountain Outing.** More than a century later, ladies enjoy their version of an outing in the Orange County wilds. Tent pitched in the trees, carriage and horse hitched up nearby, they savor a snack amid their books. Was the vintage heater brought along for cooking or heating? (Lost Woman's Canyon in the Santa Anas was named for a local schoolteacher who disappeared while exploring mountain scenery alone.) (Author's collection.)

**CHANGING MOUNTAIN LANDSCAPE.** These views from the 1960s show the route into the Santa Ana Mountains via El Toro Road. The landscape goes from desert scrub at the lower levels (below) and moves into chaparral as the road climbs before it reaches true mountain scenery (above). Chaparral includes a variety of oily evergreen plants that survive in drought but are fire-prone. They represent a majority of the terrain type of the local mountains and forest. (Both courtesy OC Archives.)

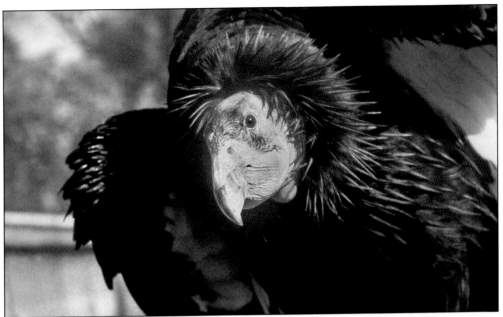

**RARE CALIFORNIA CONDOR.** Once the California condor soared over most of the mountains and foothills of the Santa Anas. Today only a precious few are alive anywhere through controlled breeding. This condor is on both California and Federal Endangered Species lists. The problems that have felled this mighty flyer, largest of American land birds, is a loss of habitat and food sources, disturbance of nest sites, hunters, and pesticides. (Author's collection.)

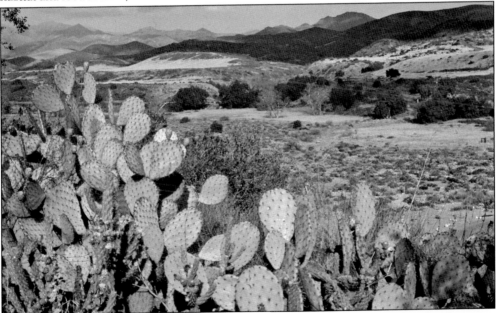

**NATIVE PRICKLY PEAR.** The valleys below the Santa Ana Mountains display the dominant prickly pear cactus, which is native to much of Orange County. Its broad, flat pads are adorned with spines, but its large, brilliant flowers and bright, edible fruit make up for the challenge of picking them. When periodic natural wildfires sweep the landscape, this cactus is threatened. (Photograph by the author.)

NATURE'S DOUBLE SILHOUETTE. The rounded silhouette of Old Saddleback and the Santa Ana Mountains had competition when it was bordered by orchards and wooded farms, here in 1983. Today it has retained these double silhouettes, thanks to the county parks that surround the mountain range. They include Irvine and O'Neill Regional Parks and Limestone/Whiting and Caspers Wilderness Parks. The scene below shows the beauty of Saddleback Mountain accented by a recovering snag, as it plays its changing role of backdrop for various locales within Orange County. (See the "Wild Parks" chapter.) (Above courtesy OC Archives; below photograph by the author.)

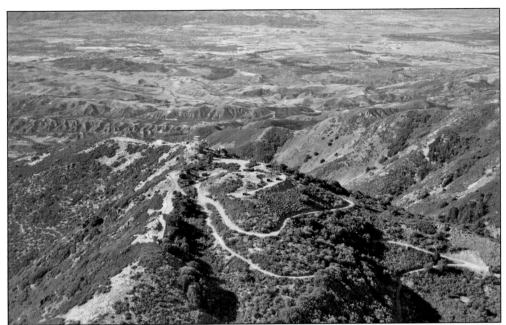

TOP OF SANTIAGO. The above view looks down at the mountainous portion of Orange County from Santiago Peak. Its wooded top, tallest of the Santa Anas at 5,687 feet, contrasts with the sparser peaks around it. The high tops standing along the Orange-Riverside County border are (from north to south) Sierra Peak, Pleasants Peak, Bedford Peak, Bald Peak, Santiago Peak, and Trabuco Peak. The second peak of Old Saddleback, Modjeska, lies totally within Orange County and is second tallest of the group at 5,496 feet. High-point Santiago Peak became the natural site of communications equipment to draw in signals from all directions of the compass. Below is an aerial view of the complex of communications towers and equipment that have expanded with the decades: this image was taken in 1995. (Above courtesy OC Archives; below courtesy USFS–Cleveland National Forest.)

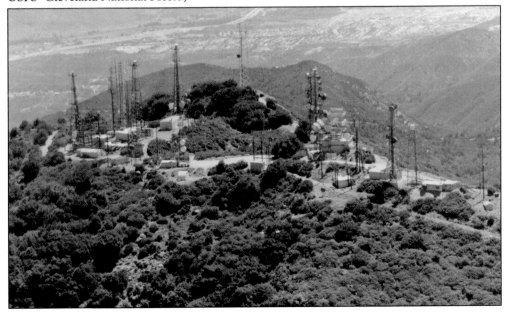

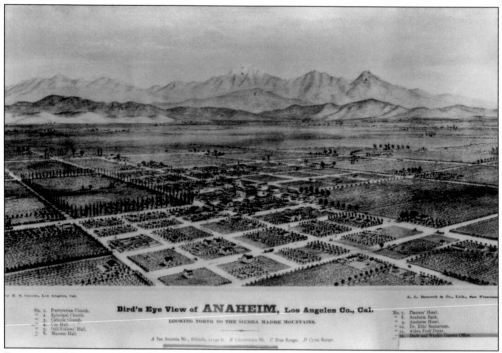

Bird's Eye View of **ANAHEIM**, Los Angeles Co., Cal.

LOOKING NORTH TO THE SIERRA MADRE MOUNTAINS.

*A San Antonia Mt., Altitude, 11141 ft. B Cucamonga Mt. C Brea Range. D Cyota Range.*

No. 1. Presbyterian Church.
" 2. Episcopal Church.
" 3. Catholic Church.
" 4. City Hall.
" 5. Odd Fellows' Hall.
" 6. Masonic Hall.

No. 7. Planters' Hotel.
" 8. Anaheim Bank.
" 9. Anaheim Hotel.
" 10. Dr. Ellis' Sanitarium.
" 11. Alden Fruit Dryer.
" 12. Daily and Weekly Gazette Office.

**BACKDROP MOUNTAINS.** Indicative of the importance of mountains to the terrain of Orange County are artists' renderings of planned developments. Here is an 1876 bird's-eye view of Anaheim showing its squares of home lots and farms. The San Gabriel Mountains form the backdrop to the north beyond the Santa Anas. Anaheim was still part of Los Angeles County and the largest city between Los Angeles and San Diego. (Courtesy Anaheim Public Library.)

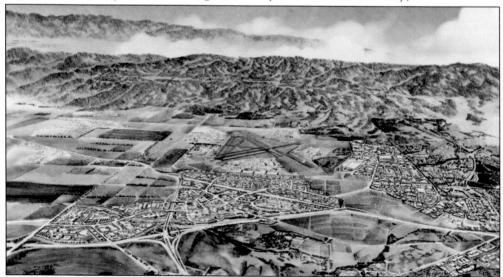

**IRVINE SPECTRUM PREVIEW.** This early preview drawing for the Irvine Spectrum project leans on the Santa Ana Mountain backdrop to enhance its layout. The Irvine Ranch, of which this parcel was part, once extended from the mountains to the ocean under single ownership—110,000 acres. As it is becoming fully developed, the Spectrum is expected to become the largest master-planned business and technology center in the nation. (Author's collection.)

**IRVINE COLLEGE CAMPUS.** The mountain backdrop dwarfs the expansive construction underway in the 1960s to create a University of California campus on 1,000 acres donated by the Irvine Company. This campus also became the focal point of a new city—Irvine, which quickly grew around it, incorporating in 1971 when it had 12,000 residents. (Courtesy OC Archives.)

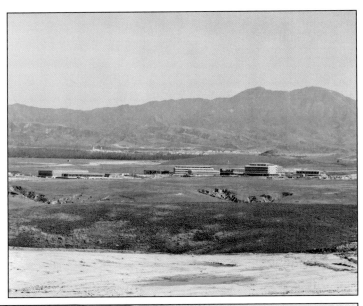

**WIDE-OPEN SPACES.** North American Rockwell chose the undeveloped foothills of the south county to construct a monumental building for its headquarters in 1971 (lower right). Its unique "stacked" design gave it the nickname Ziggurat. It was acquired by the federal government in a 1974 trade. Then located in an isolated, unincorporated area, it now carries a Laguna Niguel address and holds the National Archives' southwest records and other federal departments. (Author's collection.)

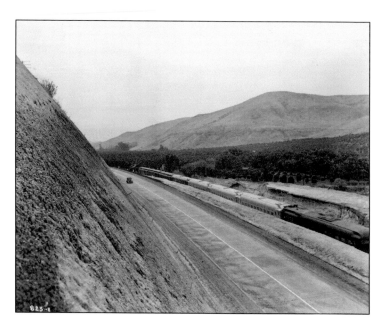

**HILLY TERRAIN CHALLENGES.** Construction projects running through south Orange County had to contend with hefty hillsides. This 1930s view shows the railroad route north of San Juan Capistrano, which is recessed through the Saddleback Valley. Highway 101 moves along above it, having required sloping of the adjacent hillside for its construction. A lone motorcar cruises along that route. (Courtesy Caltrans.)

**STOPPED BY THE HILLS.** This 1990s view from Stonehill Drive in Dana Point displays the rugged backdrop of foothills southeast of the Capistrano Valley. This geographic feature required the San Diego Freeway (the white streak across the scene) to curve coastward at that point. It was the same deviation required in construction of both the railroad and the 101 highway to redirect their routes around the foothills. (Photograph by the author.)

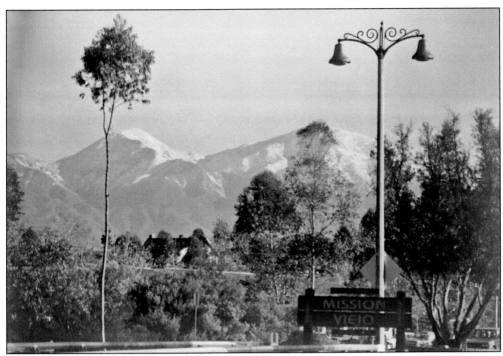

**GENUINE LOCAL SNOW.** While Orange County residents rarely see any snow here in their lifetimes, an occasional ground-level cold rain does cloak Saddleback's peaks in white. The media announces the altitude limit—"down to 3,000 feet" can create a white view, like this one from Mission Viejo. Much of the east and south sections of Orange County have perpetual views of this two-peaked landmark. (Courtesy Mission Viejo Heritage Committee.)

**PERPETUAL LOCAL SNOW.** This county does have a perpetual snowcapped mountain—at Disneyland. Built in 1959, this pointed landmark of Fantasyland is set in geographical alignment with the real Matterhorn in Switzerland. Orange County's version, though, is only one-hundredth the size of the real one—147 feet high. In addition to its bobsled tracks and Abominable Snowman, this white wonder once enclosed a small basketball court for employees. (Author's collection.)

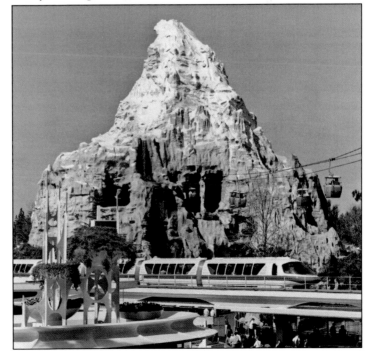

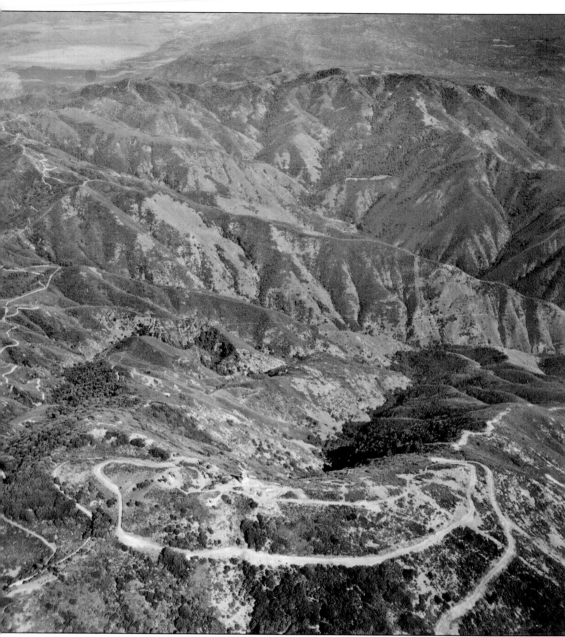

**MOUNTAINS ARE FOREVER.** Though surrounded by urban development and close to the marine influence, the Santa Ana Mountains have retained their wild character, supporting one of the last intact coastal ecosystems in Southern California. The mountains have maintained a habitat for numerous species rarely or never found elsewhere. These mountains are part of the California Floristic Province, which is said to be "a biological hot spot second only to the rain forests in diversity and richness." They are steep but with narrow to rounded summits and narrow canyons. They range from 300 feet along the Santa Ana River to 5,687 feet on Santiago Peak. All but the larger streams are dry during the summer. This 1940s aerial photograph shows the rugged natural terrain around Santiago Peak, except for the circular man-made road. (Courtesy USFS–Cleveland National Forest.)

# *Four*

# RUSTIC CANYONS

**A MEMORABLE SCENE.** "Leaving Live Oak Canyon and branching left from El Toro Road, we climbed beautiful Modjeska Grade Road. Green valleys and brown hills—gorgeous! After entering Modjeska Canyon we came upon a bird sanctuary, where we delighted in aerial antics of heavenly hummingbirds." The author wrote this note on the back of this photograph she took in 1964 and sent to an Ohio relative. It was returned to her years later among the relative's willed mementoes. (Photograph by the author.)

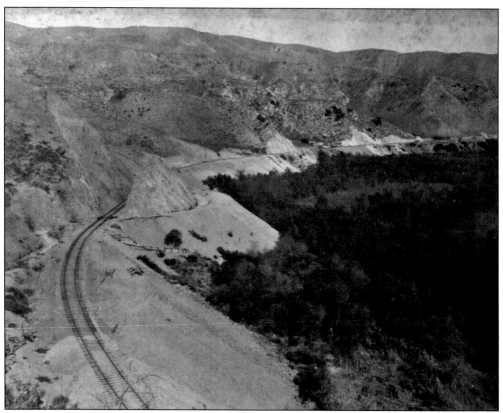

SANTA ANA CANYON. A canyon, simply stated, is a deep valley between two cliffs worn down, usually by a water source. This is the canyon that trails along the Santa Ana River. It was the choice for the 1887 railroad route when tracks were being laid through Orange County. In some places, the edges of foothills were cut away to create a smooth curve of track. (Courtesy Anaheim Public Library.)

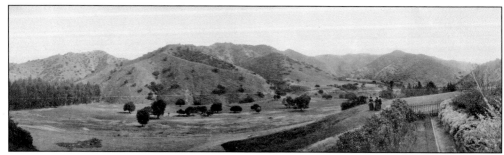

PETERS CANYON GOLF. A panoramic view from 1899 shows the section of Peters Canyon that became the Santiago Golf Club. Grass and trees decorated the links. The clubhouse was on the ridge of a hill. Today this area is within Orange County's rustic Peters Canyon Regional Park. Most of the United States has "canyons," a word that originated with the Spanish equivalent—"canada." (Courtesy Anaheim Public Library.)

**COYOTE CANYON RESTORED.** This canyon in Newport Beach was overgrown when photographed in 1963. However, in that year, the county turned it into a landfill for solid waste. It was closed in 1990, with a portion being converted into a natural area. Six feet of soil was added so a coastal sage scrub environment could be planted there, especially to support the endangered California gnatcatcher bird and its prey—gnats. (Courtesy OC Archives.)

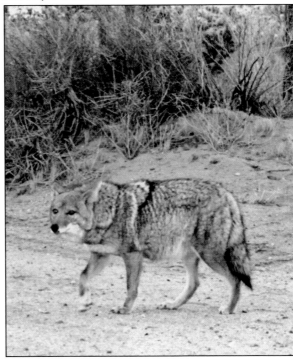

**COY COYOTE ADAPTS.** Coyotes enjoy canyons, where they can make dens in seclusion, often enlarging one left by a smaller animal. The coyote's only real enemy is a human hand carrying a gun. These coy animals have been severely persecuted, but their adaptability has kept their numbers safe. Some have migrated into the mountains, where their fur grows longer and thicker. This one is a lowland dweller, living among dry brush. (Photograph by the author.)

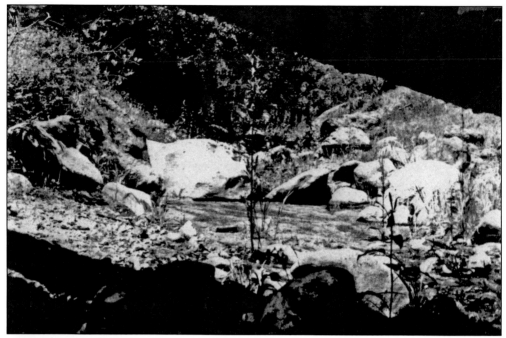

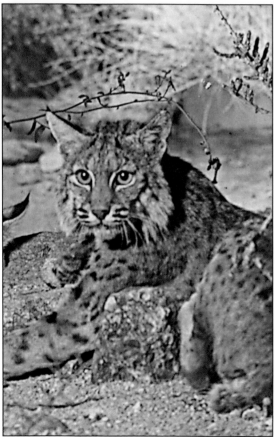

**BLACK STAR CANYON.** Archeological findings in this canyon, home of Native Americans for centuries, earned it California State Landmark status. Unfortunately, there was also a Native American slaughter there in 1831. The first European to build a cabin (of sycamore logs) called it Rancho Escondido or Hidden Ranch. However, Black Star Coal Mining Company, operating until 1894 with up to 1,500 feet of tunnels, gave the canyon its name. (Courtesy First American Corporation.)

**CANYON BOBCAT HABITS.** Western bobcats enjoy wooded canyon habitats. Named for their short bobbed tails, they resemble large domestic cats; however, they can kill animals as large as deer. Bobcats den in crevices or hollow logs, favoring hillside brush for hunting. Until 1971, bobcats and coyotes, considered undesirable predators, were fair game for hunters. Now there is limited allowable winter hunting for bobcats, whose fur is a lucrative commodity. (Author's collection.)

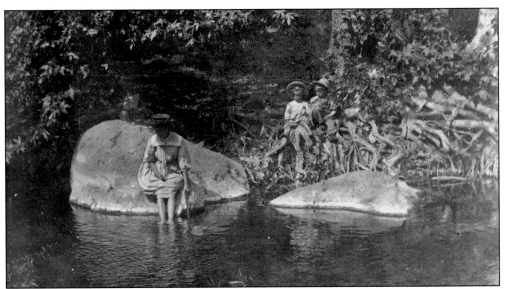

**SANTIAGO CREEK SCENE.** This *c.* 1900 Orange County scene was set by a natural swimming pool in the creek that flows through Santiago Canyon, with giant boulders, native sycamore and oak trees, and wild grapevines. This is the longest stream in Orange County and probably the longest canyon. Here, below Old Saddleback Mountain, pockets like this of pristine beauty were postcard perfect. (Courtesy OC Archives.)

**NATIVE SYCAMORE TREES.** The sycamore is native to most of Southern California, from sea level to 5,000 feet, and enjoys rooting along creeks and rivers. In that habitat, the long, straight trunks often lean from the moist, shifting soil where they thrive. This tree has interesting fruit balls, which hang in strands along the stems. (Author's collection.)

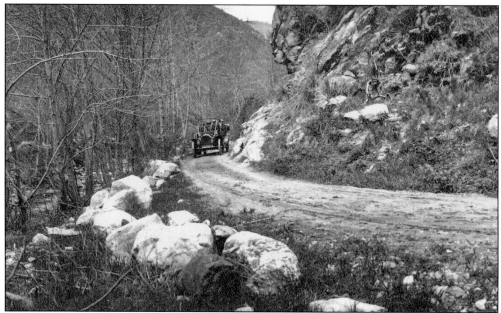

MOTOR TOURING ADVENTURE. This book's front cover photograph and those on these two pages were taken during 1913–1916 with panoramic cameras, providing memories for adventurers during outings in Santiago Canyon. Their Model T Fords, prime movers of that early motor generation, were not intended to climb mountains. Yet they ventured along the unpaved road cautiously but successfully. (Courtesy Anaheim Public Library.)

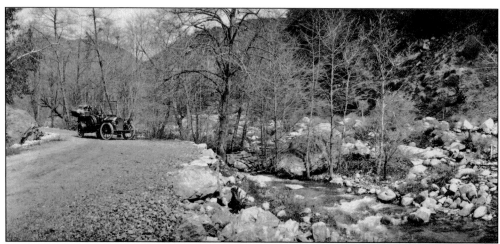

PANORAMIC CAMERA VIEWS. The Model T's slow speed enabled its passengers to soak in every aspect of the scenery along the way: the creek, the rocks, the trees, the mountains—probably some wildlife unused to visitors, as well. Everyone had to agree on where photograph stops should be made, since everything was scenic. The camera equipment would probably be a sight in itself compared to today's tiny digitals. (Courtesy Anaheim Public Library.)

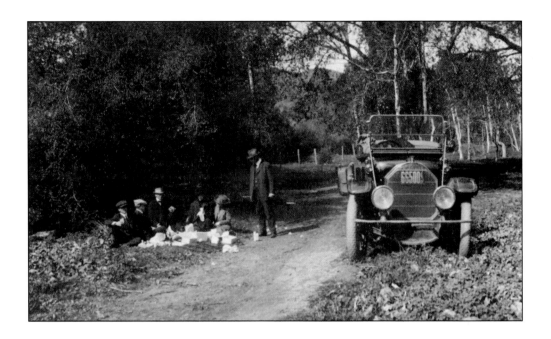

EARTHEN PICNIC TABLE. This group of adventurers (above) had a definite purpose for their mountain climb. At the edge of a Santa Ana mountain path, at a selected open spot in the woods along a trail, they cleared the fallen leaves to create an earthen picnic table. Santiago Canyon's rugged scenery was also a favorite setting for many of Hollywood's Pathe Western movies in the early 1900s, as it is for so many modern visitors. Below is an expanded view of this book's cover photograph, revealing yet more of the diverse layers of scenery. It appears that the road ahead could be downhill from there. (Both courtesy Anaheim Public Library.)

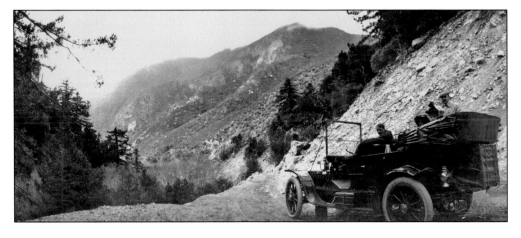

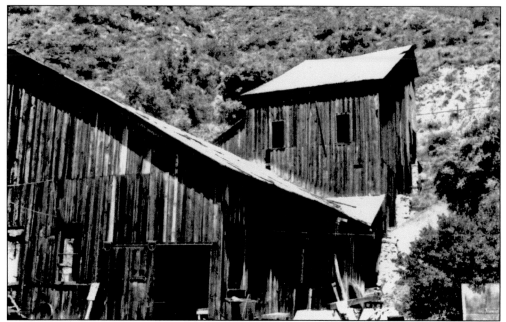

**TRABUCO TIN MINING.** South of Silverado Canyon lies Trabuco Canyon. There, in 1878, tin ore was discovered—just outside O'Neill Regional Park. The Gasparina Mining District was created, but nothing happened within it until 1904, when the Santa Ana Mining Company dug tunnels and installed a mill. The mine produced no tin, but traces of other minerals were recovered. No traces of this mining operation remain. (Courtesy First American Corporation.)

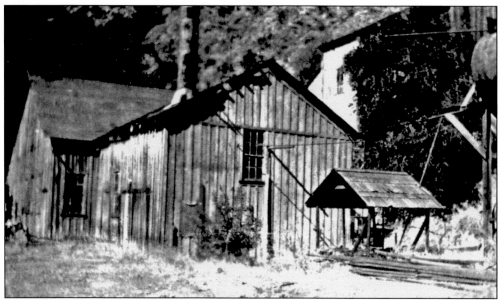

**EARLY COAL STRIKE.** Before Silverado Canyon earned that name, it was the site of an 1880s coal strike. A survey found the vein to be on property of Southern Pacific Railroad, so its early trains took advantage of fuel from this Santa Clara Mine. South of it, the town of Carbondale grew. That mine was abandoned in 1884, as was Carbondale, which did become a state historic landmark. (Courtesy First American Corporation.)

**BLUE LIGHT MILL.** Pictured are the long-gone ruins of the Blue Light Mill. Hoards of miners arrived after silver ore was found in 1877. A town site developed—Silverado, the lasting name for the entire canyon. No matter that the silver mines closed within a decade, Silverado had been a real mining town with a post office, three hotels, a school, stores and markets, two blacksmith shops, and at least seven saloons. (Author's collection.)

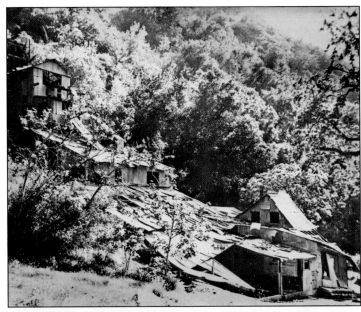

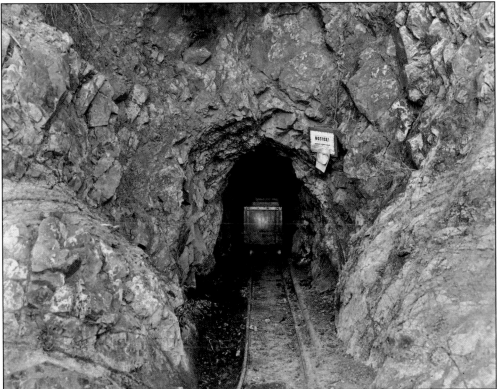

**SILVERADO MINE TUNNEL.** This is the tunnel into the successful Silverado mine. Most of the miners lived in a tent city there. Before the silver strike, this canyon was called Cañada de la Madera, or Timber Canyon, known for its useful trees. Silverado was reborn as a rustic canyon town in the 1920s when resorts and mineral springs opened. Its post office was reinstated in 1931. (Courtesy Anaheim Public Library.)

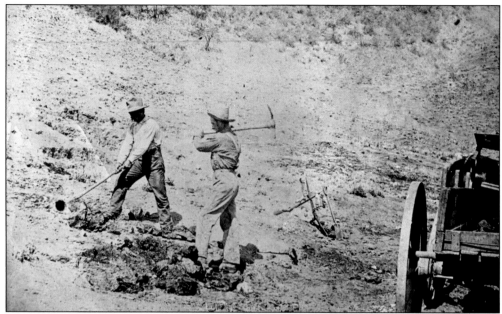

**DIGGING UP BREA.** Brea, in northeastern Orange County, received its name from the natural occurrence of tar, found in pits in the canyon given the same name. Used for waterproofing roofs and boats by Native American residents, the brea was hand-dug by early settlers for fuel and weatherproofing, as in this vintage image. The first liquid oil well there was drilled in 1882. (Courtesy La Habra Old Settlers Historical Society.)

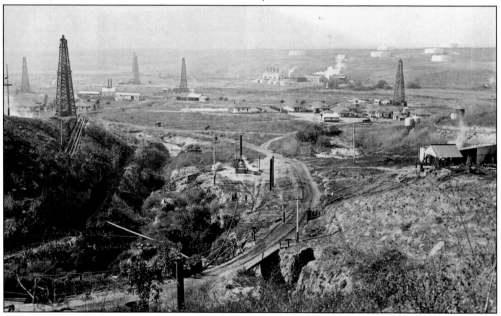

**CANYON OIL STRIKES.** This early La Habra oil field in Coyote Hills was matched throughout the county's northern canyons and northwest coast. The noisy gas engines running early oil pumps drove many native animals back into the hills. Two of Union Oil's tanker ships were named for oil-producing Orange County cities with opposite-meaning names: La Brea (the tarry place) and La Placentia (the pleasant place). (Courtesy First American Corporation.)

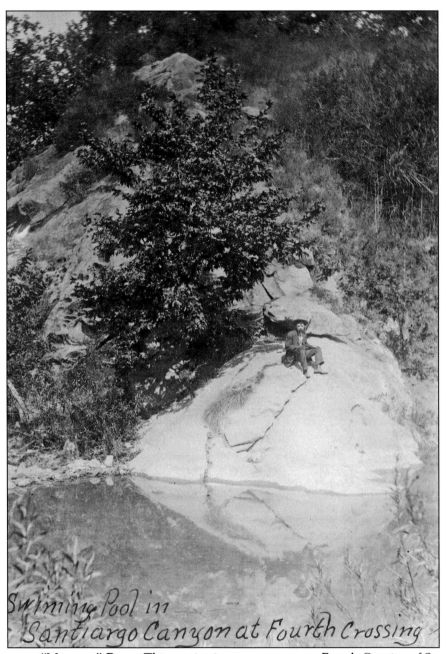

*Swiming Pool in Santiargo Canyon at Fourth Crossing*

LEGENDARY "MANCOW" ROCK. This captivating scene was set at Fourth Crossing of Santiago Creek. The bucolic spot was the fourth place the canyon road crossed the creek. Before the dawn of the 20th century, there stood a hunters' shack where young men gathered for sport—rabbits and quail their goal. One day, a group of hunters arrived to find that one hunter had brought his girlfriend. As the pair strolled along this mammoth rock, a bull from nowhere suddenly appeared. The hunters shouted, "Watch out for the mancow!" which went on to chase the pair to safer ground. After that, a sign appeared on the rock: "Beware of the Mancow." The rock vanished with arrival of Santiago Dam in 1932. That created Irvine Lake but washed out Fourth Crossing and its beautiful setting. (Courtesy OC Archives.)

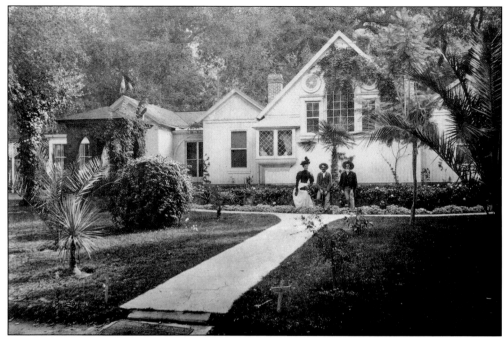

**ARDEN, MODJESKA'S HOME.** A world-famous woman who arrived in Orange County in 1876 would leave her stylish name on a canyon and the mountain above it. When Polish Shakespearean actress Helena Modjeska ventured into undeveloped Santiago Canyon, she lost her heart to the setting. Her rambling home, a documented National Historic Landmark, is an Orange County Historic Park—including her gardens. (Author's collection.)

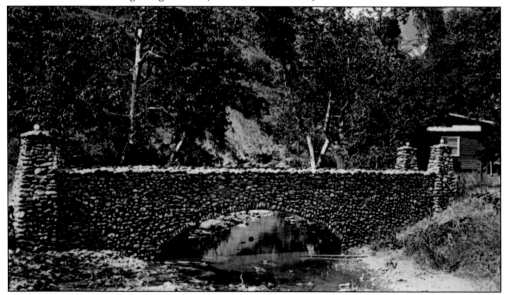

**MODJESKA'S WATER MUSIC.** Modjeska's ranch was named Arden for the forest in her favorite play. Santiago Creek flowed through the property. She was charmed by the "music of rushing brook and waterfall." After Modjeska and her husband, Count Bozenta, sold the property, it became a country club. Their wooden bridge across the creek was replaced with this one of native rocks; its pilasters remain. (Courtesy First American Corporation.)

LAKE OF ARDEN. "We spent the noon hours sitting in the cool creek and frightening the water snakes. . . . Not withstanding the inconveniences, this canyon is the most beautiful spot on earth," wrote Madame Modjeska in her *Memoirs*. She itemized the "inconveniences" as rattlesnakes, mountain lions, wildcats, and grizzly tracks. "The scenery was magnificent, at least we thought so. . . . But all our improvements had for their main object not to spoil what nature had provided. We left all the old oaks around the house. . . . Every time I came to Arden, my thoughts were far away from the stage. It was an ideal place for rest, and I needed rest." Along with visiting European friends, the couple "spent most of the summers in Santiago Canyon," but the actress continued her worldwide star performances. (Both courtesy First American Corporation.)

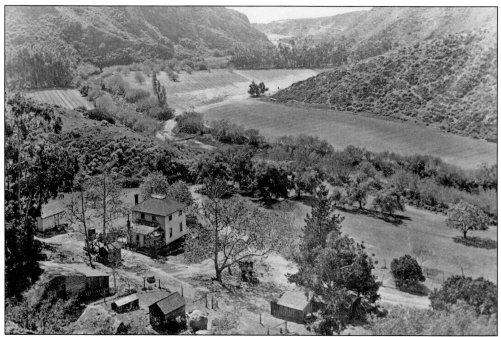

**Aliso Canyon Homestead.** In 1871, the Thurston family from Utah homesteaded in Aliso Canyon. They lived in an old shack found on the property, plus a tent, since there were six children. By 1892, Joe Thurston had completed this substantial house on the property near the coast. He planted vegetables and raised livestock. He and his sons hunted deer, rabbits, and quail and fished at the nearby shore. (Courtesy First American Corporation.)

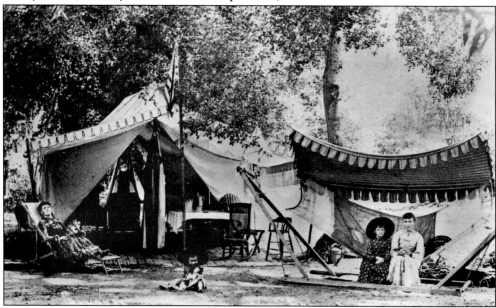

**Cozy Canyon Spa.** Camping in the canyons took on some intriguing displays of fashion in this Silverado "spa." These 1890s ladies of all ages luxuriate in an elegant tent and canopy. They are dressed in long robes to enjoy the healthful outdoor scene. Indoor dining room furniture, rug, rocking chair, and high chair all dress up the rugged outdoor life. (Courtesy First American Corporation.)

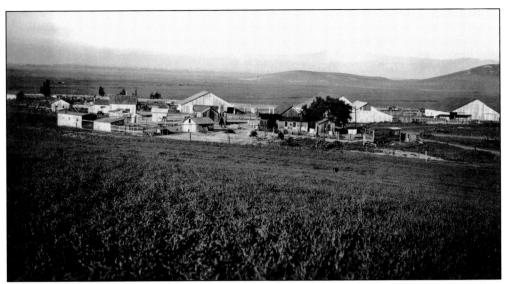

**BONITA CATTLE CAMP.** Bonita Canyon joins Culver Road at the University of California, Irvine. The Bonita once contained a kiln to burn mussel shells from Upper Newport Bay to produce lime. It also held this Irvine cattle camp, shown in 1937. Some of the old buildings and trees still survive, though development has changed the surrounding area. Bonita is Spanish for "beautiful." (Author's collection.)

**BOMMER CANYON LANDMARK.** Irvine Ranch cattle grazed within this beautiful canyon north of Newport Beach. It was there in 2008 that Earth Day observances included an announcement that 40,000 acres of the original Irvine Ranch has been designated as the first California Natural Landmark. Two years earlier, the ranch was designated a National Natural Landmark by the U.S. Department of the Interior. (Author's collection.)

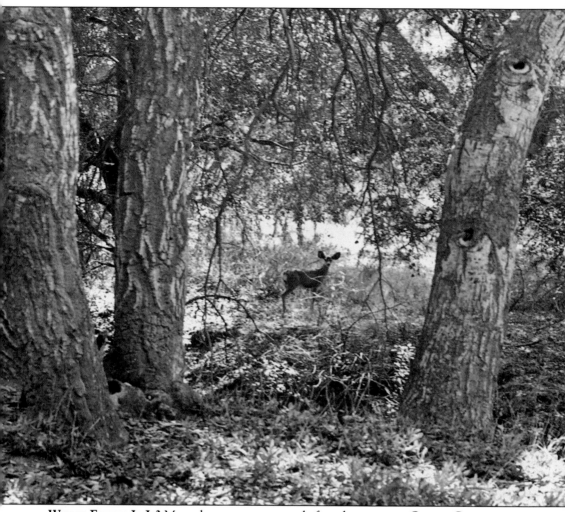

**WHOSE FOREST IS IT?** More than a century ago, before there was an Orange County, concern was rising about the need to preserve the precious but impassible forest to the east. There, in the Santa Ana Mountains, lay the primary water source for this area, which was then part of Los Angeles County. Individuals were homesteading in the forest and cutting trees; fires raged unchecked. Out-of-town visitors were penetrating beyond the trails, leaving native animals like this mule deer to look to the west, wondering what its fate would be as more time passed. (Courtesy Anaheim Public Library.)

# *Five*

# NATIONAL FOREST

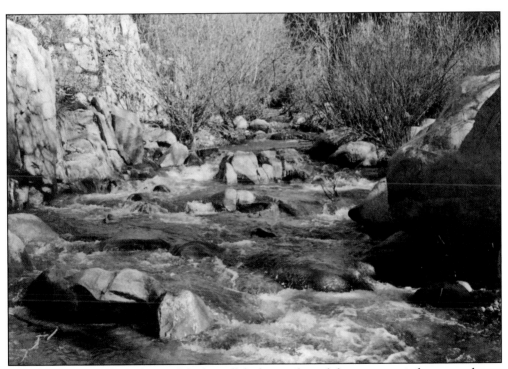

**SAN JUAN CREEK.** The rocky creek bed parallels the rough road that once carried stagecoaches to San Juan Hot Springs. It became Ortega Highway in the 1930s. The streamside scenery required construction of special turnouts as it reached Cleveland National Forest so motorists could stop and breathe in the natural beauty. (Courtesy USFS–Cleveland National Forest.)

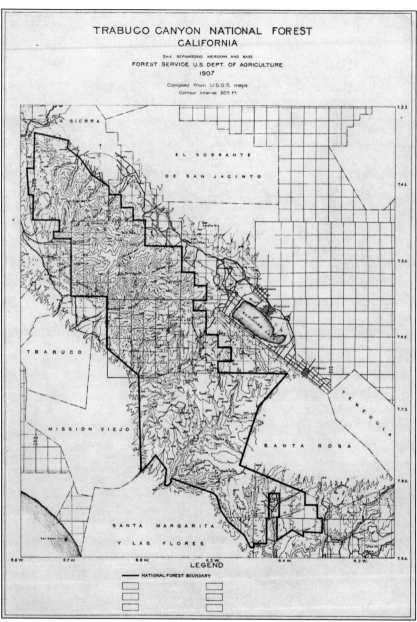

TRABUCO CANYON NATIONAL FOREST
CALIFORNIA

SAN BERNARDINO MERIDIAN AND BASE
FOREST SERVICE U.S. DEPT. OF AGRICULTURE
1907

Compiled from U.S.G.S. maps
Contour interval 500 ft.

LEGEND

NATIONAL FOREST BOUNDARY

**PRESERVE THE FOREST.** Besides individuals cutting trees and building, miners were staking claims, cattle and sheep were grazing unrestricted, and waterways were being diverted. Aimed at protecting the forest and its natural water supply, the California Forestry Commission was formed in 1886. Orange became a county three years later. The U.S. Forest Reserve Act of 1891 enabled American presidents to establish public forest reserves, and so Trabuco Canyon Forest Reserve was created here in 1893. Then Pres. Theodore Roosevelt established the U.S. Department of Agriculture–Forest Service in 1905. Trabuco Canyon became a national forest in 1907 (see map). However, the following year, two Southern California reserves were combined into Cleveland National Forest. It was named for Pres. Grover Cleveland, who had initiated wildlands control during his term despite negative voices. Today this national forest contains 460,000 protected acres but has been called "one of the most threatened wilderness areas in the world." (Courtesy USFS.)

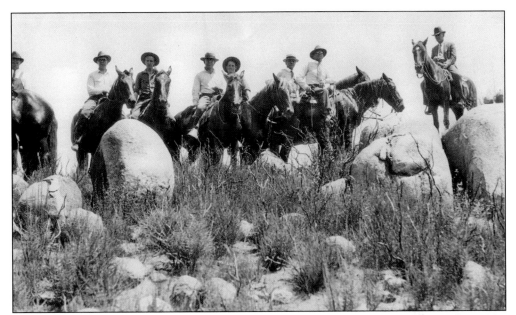

**ORANGE COUNTY ENTRY.** When motorcars took over transportation corridors in the 1920s, recreational interest in the forest grew. An entry road became essential, and Ortega Highway from San Juan Capistrano was the choice. County and forest officials held their early meetings on horseback while determining a route through desert-to-mountain scenery and around boulders and wild brush, creeks, and wild critters. (Courtesy USFS.)

**EARLY ORTEGA HIGHWAY.** The road was named for Sgt. José Ortega, chief scout in the first European expedition to pass through Orange County in 1769. It remained a rugged road through stunning scenery, improved every so often through time, even up to this day an unfinished gateway to the mountains and Riverside County. Bicycles, then motorcycles, seemed best suited for the circuitous roadway, whose edges remain green through most of the year. (Photograph by the author.)

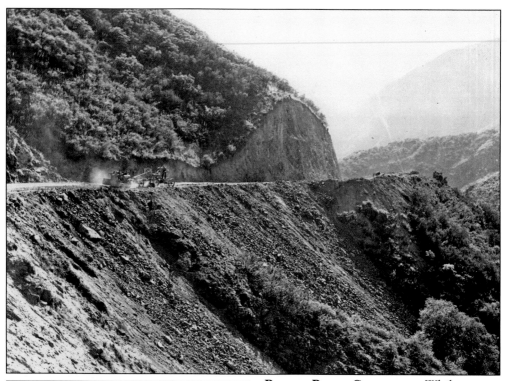

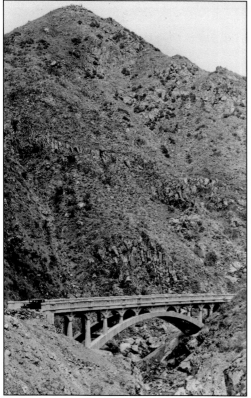

**RUGGED ROUTE CHALLENGES.** While construction of Ortega Highway was underway in the 1930s, each segment presented a challenge. After a hillside was sliced off like a piece of meat, early road scraping equipment smoothed the new roadbed (above). It created a dangerous slope below. The previous trails had been limited to horses and mules, who hauled all the necessary equipment and supplies. The dramatic bridge below connected the road over San Juan Canyon, constructed in the 1930s. Dwarfed by the mountain behind it, the bridge in turn dwarfs the early motorcar that just crossed the dramatic spot. (Above author's collection; left courtesy OC Archives.)

**WILDFLOWERS AND WATERFALLS.** The ranchland that lay along the Ortega was flush with rustic scenery, with grazing livestock and horses enjoying the fields year-round (right). The approach to the forest within San Juan Capistrano is shown here in the 1980s. Seemingly endless fields of native California poppies and other wildflowers brighten the route in spring. Where water supply is sometimes a worry, it is a thrill to encounter a natural waterfall after a serious rain. This one is near Ortega Highway, as if a welcoming display near the national forest entrance, reached on a trail less than a mile from the road. Other waterfalls flow seasonally within the forest's Trabuco District—in Holy Jim and Black Star Canyons. (Right photograph by the author; below courtesy USFS.)

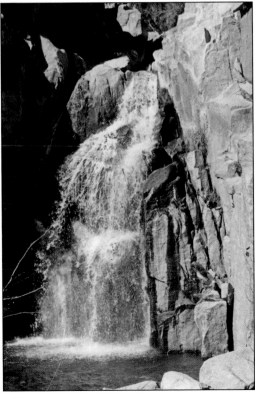

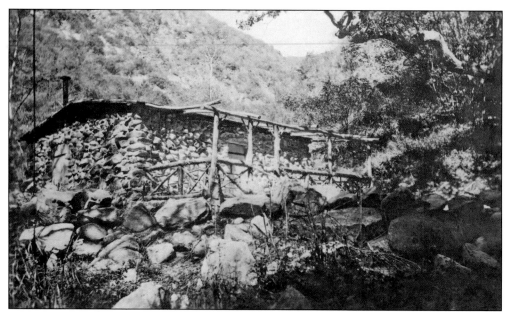

**SPECIAL-USE CABINS.** In the 1920s, tracts were established with lots for "special use" seasonal cabins within the forest. As quickly as they were surveyed, most of the lots were leased. The cabins displayed creative use of native rocks and lumber, such as this early one in Trabuco Canyon with an all-around view. (Courtesy USFS.)

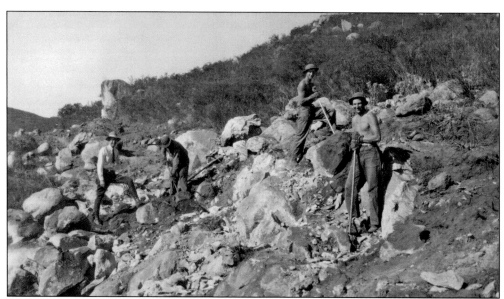

**CCC ADDS LIFE.** While the country was suffering from economic depression, Pres. Franklin Roosevelt's New Deal put new life into the national forests. His Civilian Conservation Corps enrolled and instructed young men to create needed improvements: trails, service roads, firebreaks, lookouts, erosion barriers, campgrounds, and more. Here in 1934, CCC workers construct a truck trail to open access to remote inner forest areas. (Courtesy USFS.)

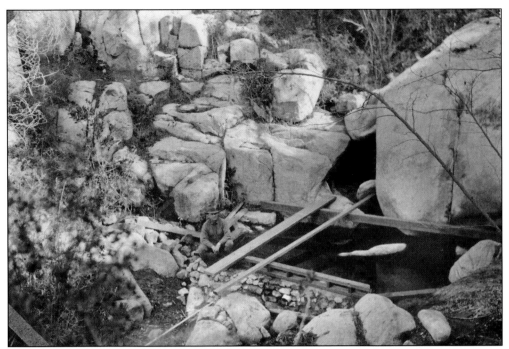

EROSION CONTROL MEASURES. Amid the forest's massive, picturesque boulders, the CCC force built measures to control erosion and preserve the flow of streams. All the while, workers and visitors had to be cautious about entering wild areas, watching for such creatures as mountain lions, bobcats, and rattlesnakes. Rangers had to also become naturalists, answering visitor queries about the special surroundings, flora, and fauna—and how to protect them. (Courtesy USFS.)

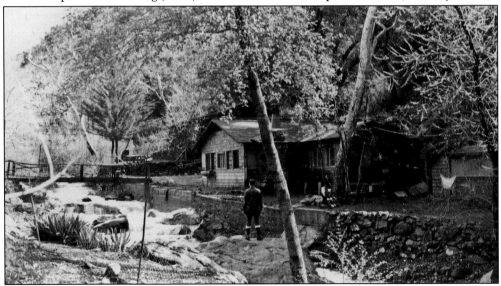

FOREST SUMMER HOMES. Silverado Creek was a popular destination for Orange County residents, for a day or a season, in the 1940s. This "recreational cabin" was one of many that lined the waterway on private holdings adjacent to the forest lands. For area families, such a getaway place in the woods fulfilled an American dream treasured during the Depression-into-war times: owning a cabin by a mountain stream. (Courtesy USFS.)

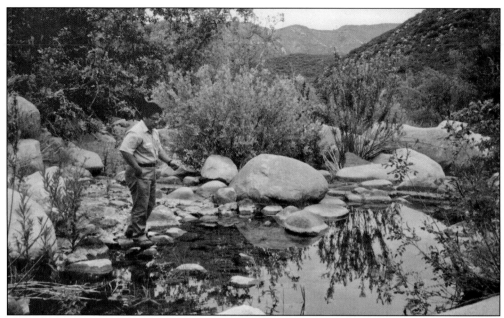

**MORE THAN TREES.** A forest's value goes beyond its trees. Scenes like this need no explanation. There is also the extensive "Elfin Forest" of native chaparral. Within the Cleveland's mountains lies the source of Orange County's natural water supply. Once the public gained entry into the inner forest, it brought increased safety concerns: fire and vandalism. However, it also brought heightened sentiment for preservation of the precious resources. (Courtesy USFS.)

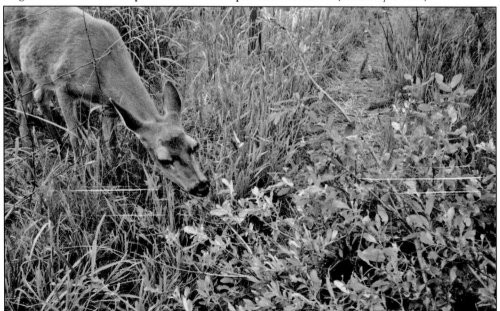

**DEER "BROWSEWAYS" CUT.** As the commitments to the forest grew over the decades, protection of the native wildlife became tantamount. During the 1960s, the Cleveland National Forest resource staff cut "browseways" through the rough brush, enabling resident deer and other animals to find their way to water holes and to gain access to the tender green shoots essential to their well-being. Ecology awareness and management grew. (Photograph by the author.)

CABINS IN THE WOODS. "Summer Home" cabin tracts were developed within the Trabuco District—in San Juan, Hot Springs, Trabuco, and Holy Jim Canyons. Pictured here are two sturdily built 1960s structures. Above is one with a Southwest theme in the San Juan tract. Below, in the Holy Jim tract, is one that made ample use of native rocks as building materials. That cabin design even included the towering live oak trees. (Both courtesy USFS.)

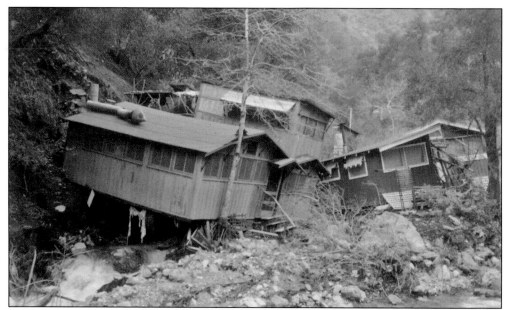

**Floods Destroy Cabins.** By the 1930s, there were 74 recreational cabins and four campgrounds within Trabuco Canyon. Even substantial cabins were threatened by the rush of creek water. The storms of 1937–1938, which flooded much of Orange County, also brought havoc to the forest. Cabins in Trabuco (above) and Holy Jim Canyons were destroyed, as was the road into the canyon. Two campgrounds were also washed out. (Courtesy USFS.)

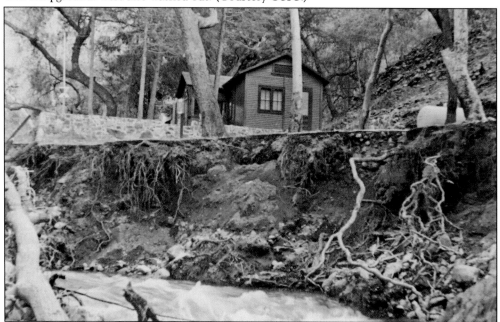

**New Leases Ended.** Another heavy rainy season affected Orange County in 1969, resulting in creek flooding and this extensive erosion in Silverado (pictured here) and Trabuco Canyons. Although the forest service stopped issuing new summer home leases in 1966, a large majority of the original "homes" still remain. Floods, fires, and occasional abandonment have slowly reduced the numbers. (Courtesy USFS.)

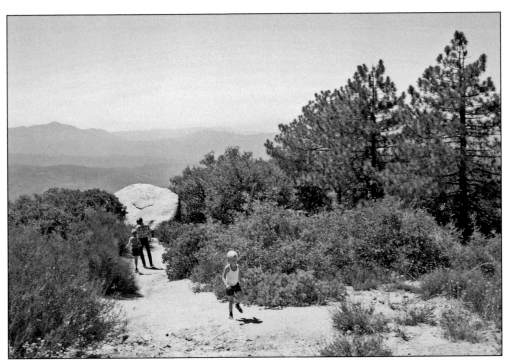

**PENNY PINES PROGRAM.** Beginning in the 1960s, a special plan was enacted allowing schoolchildren and organizations to contribute coins to fund pine tree plantations within the forest. Groups such as Scouts participate in planting events. Children learn by returning to watch the trees they bought and planted soar into grand pines above the native brush. To date, 27 million seedlings have been planted in this state's national forests. (Photograph by the author.)

**TREE-CLOAKED CAMP.** While most of the lower forest landscape is chaparral, pines and coast live oaks create shady canopies over campgrounds and picnic sites, this one shown in the 1960s. Campers seldom gather the acorns that fall from trees today, but they were the staple food of local Native Americans. The early people camped in the forest during the acorn season, gathering their supply for the winter. (Author's collection.)

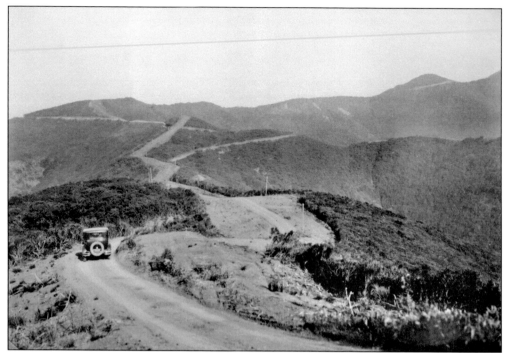

**FIRE BREAKS CUT.** The first lines of defense when forest fires occur are well-placed fire breaks, which have been graded to permit quick entry by firefighters into otherwise dense landscapes. They form interesting patterns over the hills, as from this 1930s view on a Trabuco District road. As more of the forest was opened to day picnickers and night campers, the danger of accidental or intentional fire was heightened. (Courtesy USFS.)

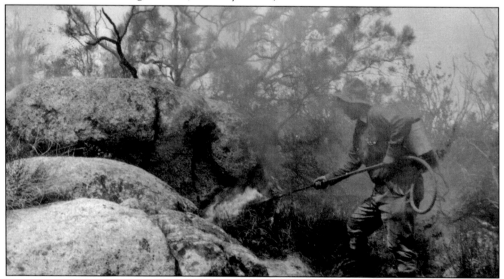

**BACKFIRE SETTING TECHNIQUES.** Even in the 1930s, as technical knowledge and equipment progressed with the times, the decision and ability to set backfires to fight real outbursts aided significantly in controlling them. Here a forest firefighter risks the added danger of facing an oncoming fire front by igniting a fire with a backpack flamethrower aimed in the flames' direction. (Courtesy USFS.)

**WHERE THERE IS SMOKE.** Fire is always more acceptable when viewed after the fact on film. In this dramatic scene, black smoke covers the sky above the winding Ortega Highway in 1955. It also belittles in comparison the size of the firefighting equipment on the road as the crew analyzes their ensuing attack on the flames. This was the Jameson Fire. (Courtesy USFS.)

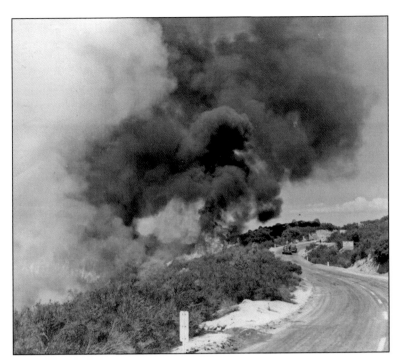

**CALL IN THE MARINES.** This national forest fire in 1958 came close to Orange County's El Toro Marine Corps Air Station, whose firefighting squad joined the forest team to extinguish it. For many years, an off-forest fire station was manned at Case Springs on Camp Pendleton, ready to react should an emergency occur at that edge of the forest. (Courtesy First American Corporation.)

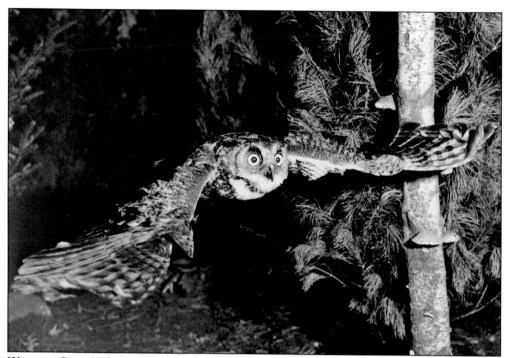

**WHO-O-O CARES?** This great horned owl is the real-life version of Woodsy Owl, a popular character introduced by the forest service in 1971. In real life, this species is plentiful in the Cleveland National Forest. Woodsy's anti-pollution slogan was at first "Give a Hoot, Don't Pollute." His message was updated in 1997 to encompass the growing interest in preserving the natural ecosystem. It became "Give a Hand, Care for the Land." (Author's collection.)

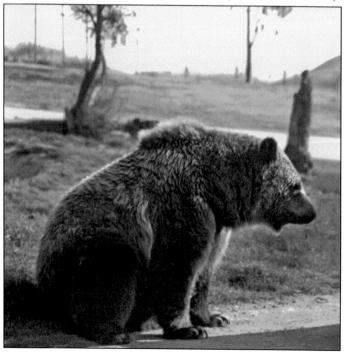

**SMOKEY BEAR'S MESSAGE.** Famous throughout the world is Smokey Bear, introduced to promote forest fire prevention in 1944. Representing him here is an Orange County native, the grizzly bear. California's official mammal is now extinct in the state. Grizzlies roamed Orange County's forest and mountains until hunters thinned their ranks. The last one here was killed in 1907 in Trabuco Canyon while stealing honey from settlers' beehives. (Photograph by the author.)

**SIGNIFICANT TREE SNAGS.**
Trees have not fulfilled their
usefulness after they die
from old age, infestations, or
fire. Known as snags, their
dramatic trunks, partly or
completely dead, can stand
alone for decades, a thing of
beauty in themselves among
the forest greenery around
them. They become lookout
posts for birds. When lifeless
outside, snags remain alive
inside. As they decay and
become hollow, they can
house nests of various species
of birds and other wildlife,
including squirrels and
bats. Snags allow sunlight
to reach the forest floor,
giving smaller plants added
life. These are all reminders
that tree snags need human
protection for the future
wildlife generations they
enfold. (Above courtesy
USFS; below photograph
by the author.)

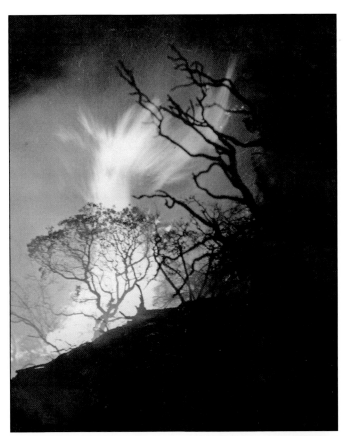

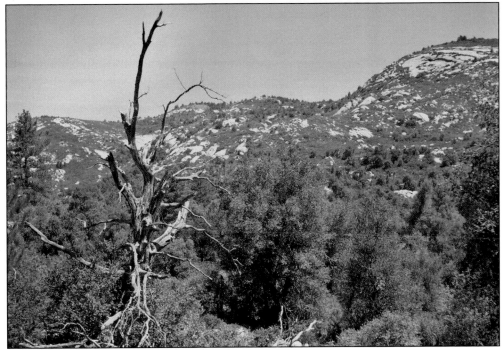

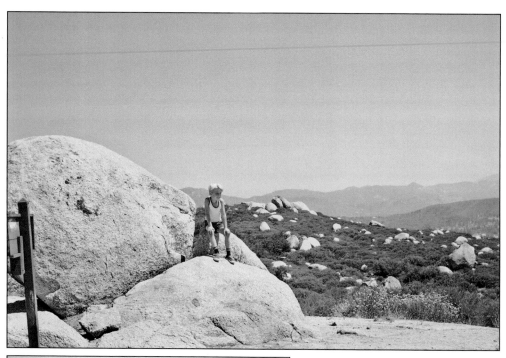

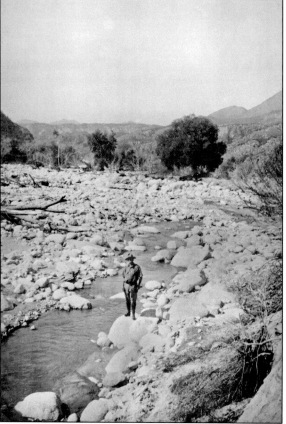

**POINT OF VIEW.** To a young hiker who has ascended a mountain trail, a rest on a mammoth rock affords a moment to look proudly down the height he has climbed while assessing the beauty in the scenes he had covered. To a seasoned forest ranger (left), standing at a rocky creekside and looking up to the mountain gives the satisfaction that he has been part of the three-dimensional wonderland of a natural forest. The Trabuco District of Cleveland National Forest to date encompasses about 120 miles of wooded trails, enabling youngsters and even disabled persons in some areas to penetrate the natural scene. (Above photograph by the author; left courtesy USFS.)

*Six*

# OC ROCKS

**ROCK OF AGES.** This large chunk fallen from Dana Point's headlands is San Onofre Breccia, a bedrock formation containing fragments of older rocks. The rare bluish schist cemented within it is an estimated 150 million years old. This ancient schist is exposed only at a few coastal points and on the channel islands, thus the theory that Catalina was once connected to Dana Point by a prehistoric mountain range. (Photograph by the author.)

CASTING FOR FUTURE ROLES. Excavations in Orange County during the past half century have uncovered a monumental mix of fossils from land and sea animals. The pictured "rocks" are really whale bones, hardened and preserved by mineral elements in the soil that covered them in San Clemente. They are encased on-site in plaster casts for protection until they can be curated. Careful cleaning to separate animal remains from rocks, in which they spent millions of years, produces such prize specimens as the complete 27-foot baleen whale skeleton, shown partially below. Discovered in the roadbed of the San Joaquin toll road, this fossil is displayed at Clark Regional Park Interpretive Center in Buena Park. Complete whale skeletons to 90 feet long and buried to 30 feet have been saved because Orange County laws protect all fossils uncovered here. (Above courtesy Mark Roeder; below courtesy Stephen Francis.)

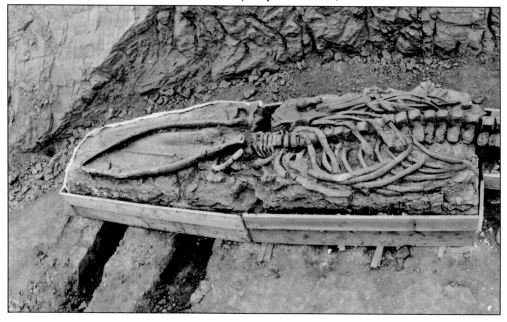

INLAND SHELL REEF. This unique ocean "reef" of fossilized limestone and seashells (above) extends for several miles inland though Laguna Hills, evidence that much of Orange County had an early undersea existence. This historical feature can be seen from a trail within Aliso and Wood Canyons Wilderness Park. Even the skeleton of a one-of-a-kind porpoise that swam through the inland reef and was embedded there, along with whales and dolphins, has been recovered. This specialized paleontological landmark is called Pecten Reef for the pecten (scallop) shells solidified within it. The standard pen included in the photograph below shows that each of the pecten shells was 5 to 6 inches long (below). (Both courtesy Carol Stadum.)

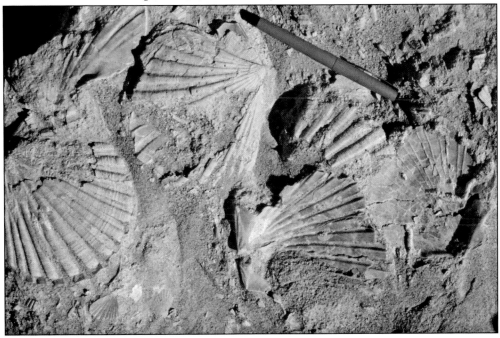

**INDIAN GRINDING ROCKS.** Acorns were the staple food of local Native Americans. This required cracking then grinding the nuts in portable hollowed stones (metates) with pestles (manos). Large communal grinding rocks like this were also used, called gossip rocks because they enabled women to grind acorns together while sharing news. The pictured grinding rock was found at a Black Star Canyon native village site. Another is in Caspers Wilderness Park. (Courtesy First American Corporation.)

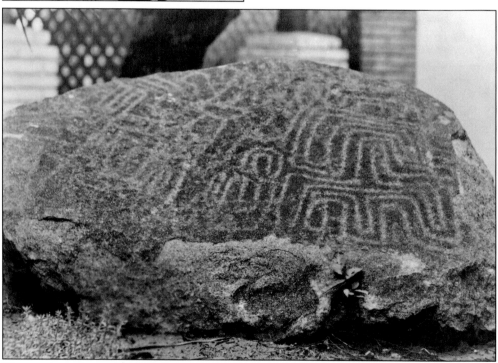

**NATIVE AMERICAN MAZE ROCK.** Carefully inscribed maze-like markings on this rock, found in the Trabuco/Bell Canyons area, may have been inscribed by a Native American shaman. The 8-ton boulder is 6 feet long. Similar Southern California rock art also occurs on exposed eastern faces of large boulders near camp or village sites. Bell Canyon itself was named for a large rock that rang when struck. (Courtesy Santa Ana Public Library.)

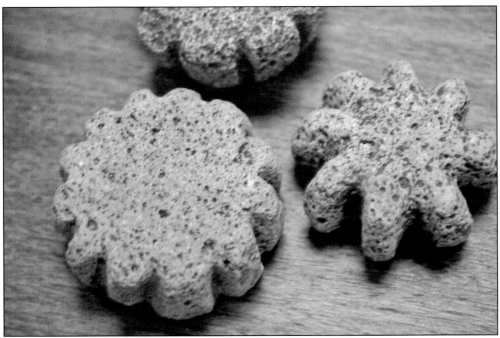

**MYSTERIOUS COG STONES.** The most unique and yet unexplained artifacts left by Orange County Native Americans are cog stones. Found mostly along the Santa Ana River and the north coast where villages occurred, they are finely carved and measure a few inches in diameter. Whether they were used for ceremonial or utilitarian purposes has not been determined. They are attributed to people of Milling Stone Horizon culture, 6000–3500 BC. (Photograph by the author.)

**NATURAL ROCK PROFILE.** The ancient bedrock of Dana Point's headlands has unusually dramatic features. They form the profile of a Native American, worn by nature into the rock. The "chief" seems to be watching the sea while guarding the natural coastal treasures. This rock profile comes into view only at select spots within the harbor—at the marine preserve and at the west end of Dana Island. (Photograph by the author.)

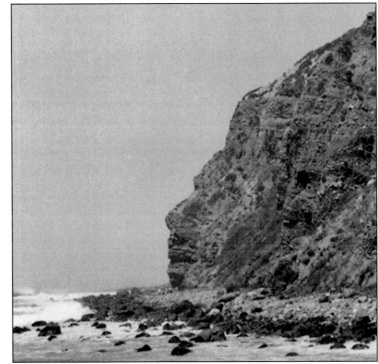

**LAGUNA CANYON CAVE.** A cave has been defined as a natural void within a rock large enough for a human to enter. Those in Laguna Coast (above) and Limestone Canyon Wilderness Parks not only satisfy that criterium, but have historical references to humans lurking or living inside—usually outlaws or bandits. Today these water-worn sandstone voids provide shady rest stops on hiking trails within the parks. (Photograph by the author.)

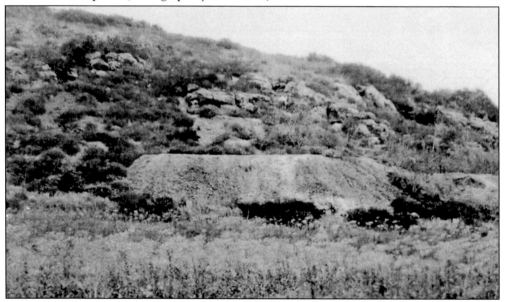

**REDHILL QUICKSILVER SITE.** The ore of quicksilver (mercury) is cinnabar. This mound in Tustin marks the site of a cinnabar mine on the San Joaquin (Irvine) Ranch. Rattlesnake Hill Mercury Mine opened in 1884, producing on and off through that century. World War I brought a high price for mercury, and mining occurred again. The red clay and red ore gave that area (and main street) the name Redhill. (Courtesy OC Archives.)

CURIOUS ANCIENT CONCRETIONS. Geologists analyzing the soil prior to construction of the 1980s Lantern Bay development in Dana Point were surprised to find this outcropping of rust-colored concretions protruding from the weathered cliff-sides. In the sedimentary rock, iron oxide "cement" has filled spaces between the grains of sand. The concretions become harder than the host stratum and therefore last, while the surrounding soil erodes. (Courtesy Marilyn Morgan.)

LIMA BEAN BOULDERS. Turning to the vegetable kingdom, a pile of rocks in Costa Mesa honors lima beans, a major crop here in the past. California Scenario is a walk-through sculpture garden dedicated to the local environment by famous artist Isamu Noguchi. One dramatic feature is this 28-ton sculpture, *Spirit of the Lima Bean*, combining 15 large granite boulders cut and fitted together. (Photograph by the author.)

**SEAL RESTING ROCK.** Here and there along the Orange County coast, massive rocks resist the ebb and flow of tides, maintaining their tops above water, therefore providing resting platforms for wildlife without their need to come ashore. This Seal Rock off San Clemente harbors sea lions and seals. Another Seal Rock exists off Laguna Beach, which also has a Bird Rock enjoyed by gulls and other shore birds. (Photograph by the author.)

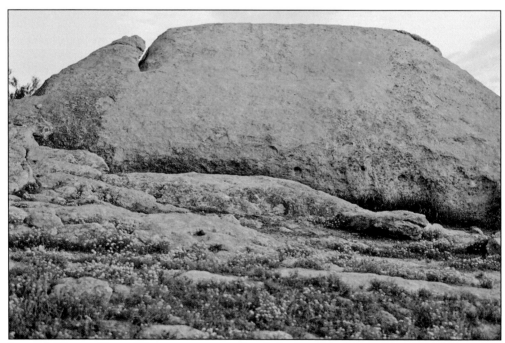

**IRVINE'S TURTLE ROCK.** This massive natural rock formation in Irvine appears to be a resting turtle. Local affection for it caused one of the city's five original neighborhoods and its major circular drive to be named for it. Wildflowers bloom around it, and shells are embedded in its base, making it a noble centerpiece for the residential setting adjacent to the University of California, Irvine, campus. (Photograph by the author.)

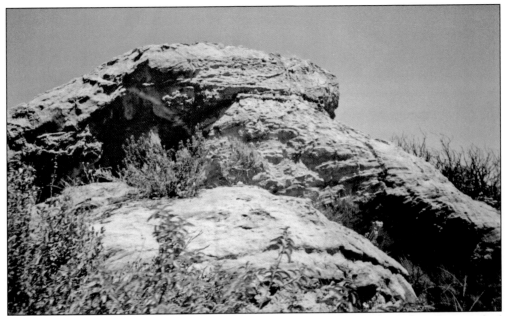

**TWO FRIENDLY WHALES?** Rock formations abound in Orange County. The author photographed this one in Laguna Coast Wilderness Park. She unofficially named it Friendly Gray Whales, in honor of the marine mammals that migrate by each year and whose ancestors' bones have been found throughout Orange County. There is also a rock Whale Island at Three Arch Bay. (Photograph by the author.)

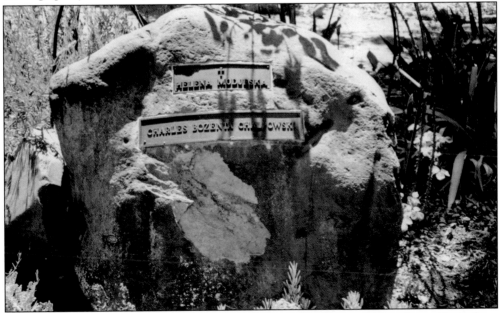

**MODJESKA MEMORIAL ROCK.** Distinctively set boulders hold commemorative plaques throughout the county. This one sits in the rose garden of Arden, Madame Modjeska's home in the canyon named for her. Her husband, Charles Bozenta Chlapowski, created this memorial to her when she died in 1909. A second plaque was added for him when he died in 1914. Docents of this Orange County Historical Park replanted the roses in her honor. (Photograph by the author.)

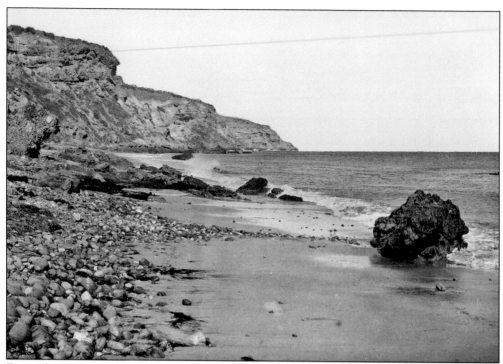

ROCKS SAIL AWAY. The tidal strand within Dana Point's natural coves, pictured here in the 1880s, was strewn with large, multicolored, wave-washed rocks. They and those hidden in the shallow offshore waters had prevented the trading ships of the mid-1800s from anchoring close to shore. However, many of these stones were carried into the cowhide-laden ships as ballast, then hauled around South America's Cape Horn and north in the Atlantic to New England—a journey of more than 14,000 miles. There the cowhides supplied the booming Boston leather industry, and the rocks became raw material for the cobblestone streets, pictured below. Such rocks still cover the beach of the Dana Point marine preserve, now protected along with the sea life that lives there and in the tide pools. (Above author's collection; below photograph by the author.)

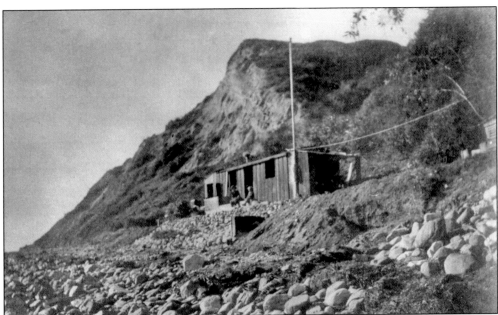

**DANA COVE ROCKWORK.**
When early fishing families built simple shacks within Dana Point coves in the early 1900s (above), each front yard down to the sea was covered with native rocks. During the 1920s, the management of the first residential tract on the bluff-tops constructed a rock-lined path from the bluff-tops down to the cove. There was built an open picnic pavilion of the abundant native rocks—the Scenic Inn (right). It was reminiscent of the natural cabins in the Santa Ana Mountains. The unprotected rock pavilion suffered neglect during the 1930s Great Depression and was washed by waves into a pile of rocks again. Some of the ruins were preserved in the 1950s in construction of a barbecue/restroom building at Dana Point Harbor's west end. The Ocean Institute now displays native rocks as accents throughout its harbor landscape. (Both author's collection.)

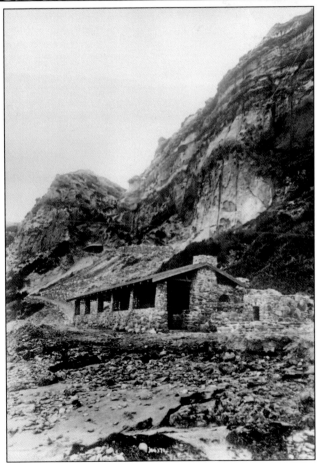

Irvine Park, Calif.

**GIFT FOR GENERATIONS.** Within his vast ranch that stretched from ocean to mountains, James Irvine II gave a 160-acre parcel in Santiago Canyon to the new County of Orange in 1897. It became California's first county park. Irvine asked that the natural setting be protected and that its grove of ancient coast live oaks be given special care. Named Orange County Park then, in 1928 it was renamed Irvine Regional Park for its donor family. (Courtesy OC Archives.)

**COAST LIVE OAK.** The long, slim acorns of this species were the staple food of local Native Americans, who learned they had to grind the acorn nuts then leach the flour several times to remove the bitter tannic acid before the flour was edible. However, that bitter acid does protect the tender leaves of the sprouting seedlings from nibbling wild animals. (Author's collection.)

# *Seven*

# WILD PARKS

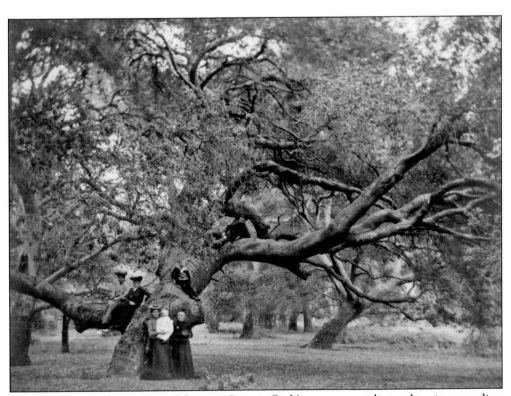

**OAK SPREADS BEAUTY.** One of Orange County Park's many coast live oaks—its spreading branches like welcoming arms—became the setting for this *c.* 1900 multigenerational Dittmer family photograph. The spread of a live oak can reach nearly twice its height of up to 80 feet. They line county canyons to about 3,000 feet altitude. The largest ones in Orange County have been growing here for hundreds of years. (Courtesy Anaheim Public Library.)

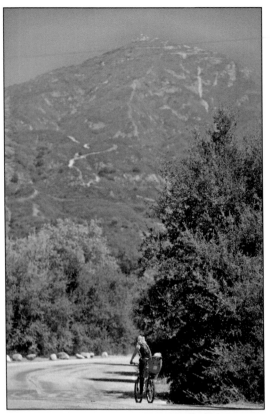

**O'NEILL REGIONAL PARK.** The owners of Ranchos Trabuco and Mission Viejo established what became known as O'Neill Regional Park in 1950. Additional land donations were made by the O'Neills over the years. The 1964 Arroyo Trabuco addition covers mostly natural terrain in a wilderness preserve. Trails enable hikers and bikers to get back into the wilderness areas. A trail system links the foothills with the ocean at Doheny State Beach. Acorn Day is celebrated annually in O'Neill Park, which is alive with oaks and western sycamores. It is inhabited by mule deer and other wildlife, with golden eagles soaring overhead. Two creeks—Santiago and Trabuco—meander through the heavily wooded terrain. (Left courtesy OC Parks; below courtesy OC Archives.)

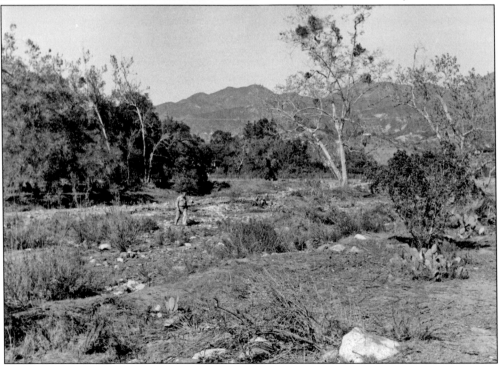

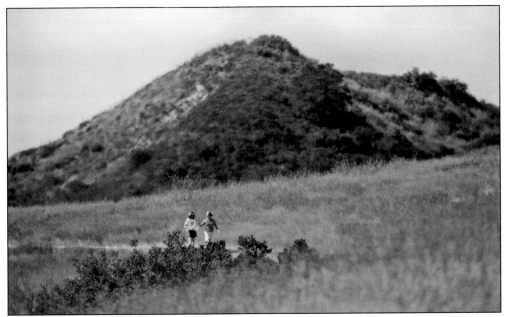

RILEY WILDERNESS PARK. This 475-acre wilderness park is also a wildlife sanctuary. The area that was Wagon Wheel Ranch was renamed in 1994 for U.S. Marine Gen. Thomas F. Riley, who in retirement became an Orange County supervisor. Trails wind through grasslands and rolling foothills and along two seasonal streams. The major ranch crop was barley, so it remains a favorite browsing spot for mule deer. (Courtesy OC Parks.)

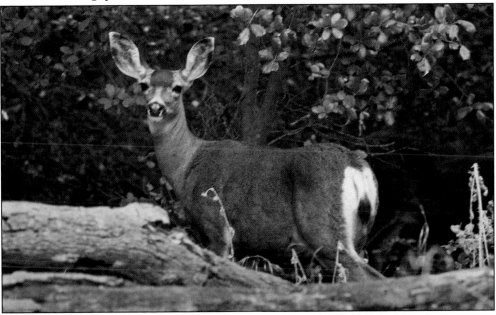

NATIVE MULE DEER. Its large ears gave it its name, and its tail added an alternate designation—black-tailed deer. This one, browsing through an oak grove in Riley Wilderness Park, shows both to the camera. The male of the species grows to 6 feet in length and to 3 feet tall at the shoulders. These deer feed on grasses, twigs, bark, buds, berries, mushrooms, cactus fruit—and even acorns. (Courtesy OC Parks.)

**LIMESTONE CANYON/WHITING RANCH.**
Scenic surprises are the keynote to this wilderness park set in 4,300 acres of deeply forested canyons, grassy hills, and seasonal creeks. The major reward occurs on viewing beautiful Red Rock Canyon, a magnificent limestone formation, along with the geological wonder appropriately named the Sinks. The park's interpretive center explains the setting, its geology, and its wildlife. (Courtesy OC Parks.)

**LIMESTONE HIKERS CAVE.** As if a forest, canyons, woodlands, streams, and red rock wonders were not enough rewards for explorers in Limestone Canyon/Whiting Ranch/Wilderness Park, these hikers have happened upon a natural cave. Legends abound about outlaws and bandits who hid out in such geological creations. Whiting was the family who owned the ranch that is now part of this park. (Courtesy OC Parks.)

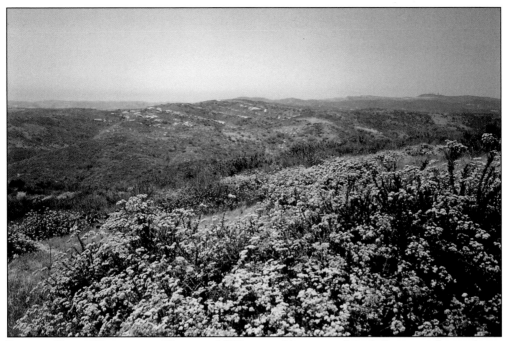

LAGUNA COAST WILDERNESS. This vast 6,500-acre wilderness park includes areas of coastal sage scrub, maritime chaparral, oak woodlands, riparian habitats, and natural lakes. Sycamore Canyon, reached by Sycamore Trail, leads through a large stand of that native tree species. Wildlife sanctity is the rule of hiking trails and guided bird walks. Views range from ocean panoramas to mountain ridges. Picturesque rocks and caves decorate some of the Laguna Canyon landscape. Legend has it the caves provided sanctity for 1800s robbers awaiting the passage of stagecoaches that barreled through rugged Laguna Canyon to the coast. Rare native plants cling to some area cliffs. The Nix Nature Center answers questions about it all. (Photographs by the author.)

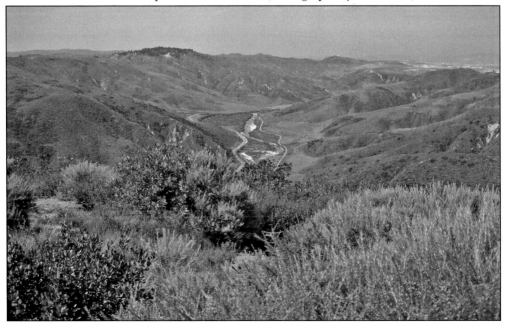

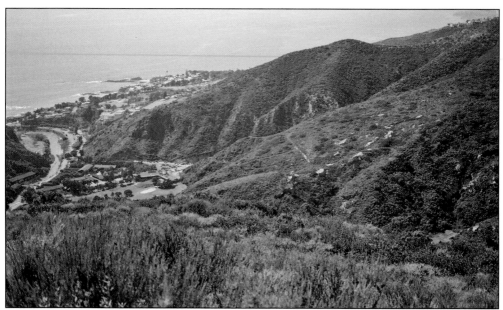

**ALISO AND WOOD CANYONS.** This wilderness park of 4,000 acres lies at the south end of Laguna Greenbelt. The two canyons provide a vivid view of Orange County's natural terrain. The southern tip is called Badlands Park (above) for the upper cliffs' pleasant erosion. An interpretive trail explains its geologic origin. The view from the park trail overlooks Aliso Cove of Laguna Beach, the ocean, and some channel islands. (Photograph by the author.)

**MOUNTED PARK ADVENTURERS.** Aliso and Wood Canyons Wilderness Park's vast grasslands, rolling hills, mature trees, and flowing creeks invite equestrians to explore much of its wilder attributes. Other features of this park include stands of native sycamore and elderberry trees, petroglyphs, a fossil reef—and even a dripping cave. See www.OCParks.com for details and locations of all Orange County parks. (Courtesy OC Parks.)

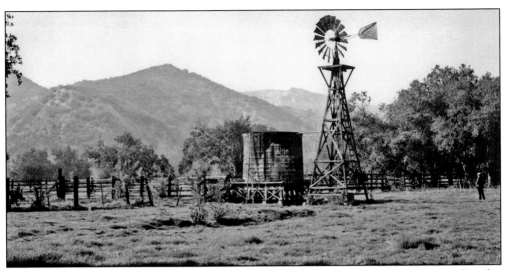

CASPERS WILDERNESS PARK. Orange County's largest park comprises 8,000 acres, set at the edge of the Santa Ana Mountains and Cleveland National Forest. The vintage windmill, water tank, and corral are remnants of its ranching past, adding historic color to its rustic campgrounds. This protected wilderness park is comprised of sandstone canyons, riparian terraces, and groves of live oaks and sycamores. (Photograph by the author.)

CASPERS PARK NAMESAKE. This wilderness park was renamed in 1974 for former supervisor Ronald Caspers after he was lost at sea on a fishing trip. He had worked diligently to acquire this portion of the Starr-Viejo Ranch for the county. Wildlife is active year-round, and wildflowers decorate the terrain in spring. From its interpretive center and on the trails are lookout points into the wilderness areas. (Courtesy OC Archives.)

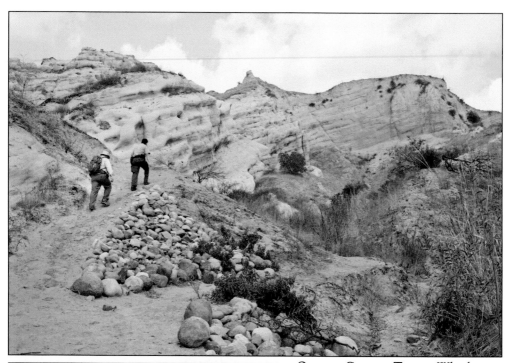

**ORANGE COUNTY TRAILS.** Whether it is hiking uphill or straight ahead, on horseback or on foot, the paths to travel into natural country are a major attraction of all county wilderness parks and most regional parks. Here are two selected scenes to represent the hundreds of miles of hiking, biking, and equestrian trails that wind through the County of Orange's vast park system. Above is a scene along Borrego Trail, where the prize of the hike is arriving at the Sinks within Red Rock Canyon in Limestone Canyon and Whiting Ranch Wilderness Park. At left, after a pleasant uphill climb, this hiker will come upon a rewarding view of scenic Upper Newport Bay. (Both courtesy OC Parks.)

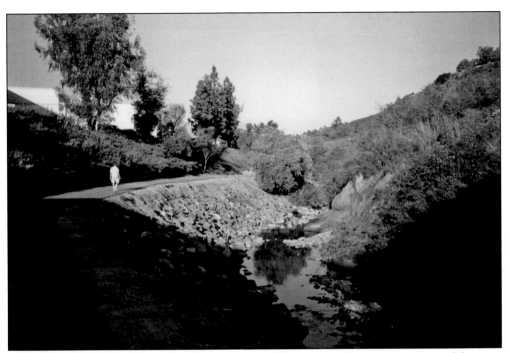

**OSO CREEK TRAIL.** Among many trail systems created by Orange County cities, one of the most picturesque is Mission Viejo's Oso Creek Trail. It winds from Marguerite Parkway to Olympiad Road. The seasonal creek flows alongside it, but during drier weather, its bed stays blue—as an artful mosaic tile creek bed is revealed (below). Other tile work along the trailhead wall tells the city's history. Hikers are rewarded along the way with a butterfly garden, a circular plant maze to meander through, a display of local fossils, an arts bridge, a peace obelisk, and special gardens planted by community volunteers—all created since 1997 in annual Tierra Nativa celebrations. They serve to honor Arbor, Earth, National Trails, and Volunteer Connection Days. The trail's potential 6-mile length will connect with other trails. (Photographs by the author.)

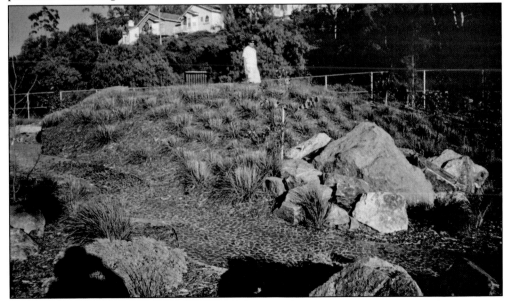

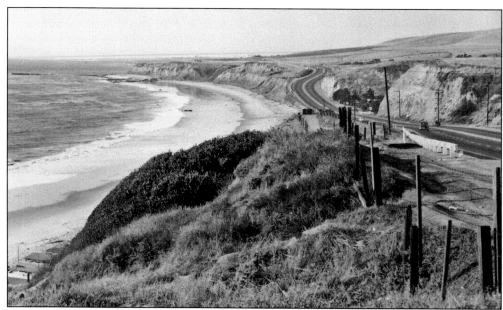

CRYSTAL COVE PARK. This state park includes classic beach and hillside terrain appreciated by both sea and land lovers. It even includes an offshore, protected 1,140-acre underwater park for divers and snorkelers. Swimming is also an active sport at this park. The above photograph from the early 1900s shows the then-untouched terrain, except for an unpaved coastal road. The state park extends from Treasure Cove of Newport Beach to Abalone Point of Laguna Beach. Land trails begin with chaparral and wildflowers, then move into uphill woodlands and backcountry canyons. Crystal Cove rental cottages (below) offer a touch of historic beach life of the 1920s, the equivalent of the inland "mountain cabin by a stream"; here the ocean plays that proverbial role. (Above courtesy OC Archives; below author's collection.)

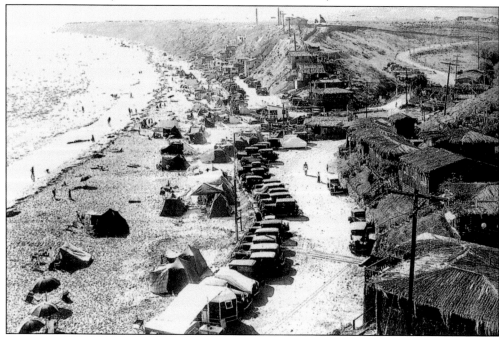

*Eight*

# PRESERVING NATURE

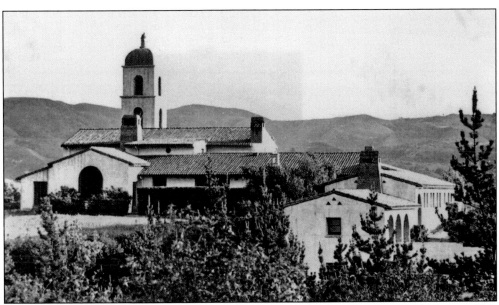

**PIONEER BOTANIC GARDENS.** In 1927, Susanna Bixby Bryant took pride in her "wild native garden" on her Rancho Santa Ana (now Yorba Linda). She recognized the need to preserve its 6,000 native species. In 1951, her garden was relocated to Claremont but is still called Rancho Santa Ana Botanic Gardens. Today the 86-acre garden is the largest in California devoted exclusively to its 2,000 native species. (Courtesy OC Archives.)

FULLERTON ARBORETUM. Within the campus of the University of California, Fullerton, is a 26-acre oasis—a garden devoted to California native plants. This arboretum displays species from coast, deserts, woodlands, and channel islands. On this page are shown two sections of the arboretum's collections. Above is a view of a rock garden featuring a native plant found among chaparral and sage scrub. It is called canyon silver or woolly sunflower (woolly leaves and yellow flowers). The image at left combines three popular species within California's magnificent wildflower spectrum. Goldfields is a yellow daisy-like flower named for gold mining areas. An early Spanish-American deck of cards featured a Jack holding one. Growing here with goldfields are baby blue eyes—a bright wide-ranging succulent—and (purple) owl clover. Its Spanish name means "little broom." (Both courtesy Fullerton Arboretum.)

**UC IRVINE ARBORETUM.** When the University of California, Irvine, was organizing in 1964, this 14-acre arboretum was established to hold campus landscaping plants. Later it took on a dedication to preserve rare and endangered California plant species and those suited to this Mediterranean climate. It also maintains a native plant gene bank. Here are representative cactus and succulent species from the Maritime Succulent Scrub Collection. These natives favor the fringes of desert into coastal scrub areas. At right is the un-huggable teddy bear cholla. Its translucent spines look like soft fur but can easily enter the skin and flesh of the unwary. Below is a member of the diverse dudleya succulent family—the green dudleya. This arboretum is adjacent to the San Joaquin Marsh Reserve. (Both courtesy UCI Arboretum.)

**TUCKER WILDLIFE SANCTUARY.** Hummingbirds rule this 12-acre wild preserve in Modjeska Canyon. Its extensive feeders attract various species. The first experimental feeders were set by Benjamin Tucker in the 1920s. After his wife died and his cottage burned, he deeded the property to California's Audubon Society. Now it is operated by a Cal State Fullerton foundation. Modjeska Canyon Nature Preserve is near Tucker. (Photograph by the author.)

**BUTTERFLY GARDENS.** This queen butterfly was "captured" by a camera in Riley Wilderness Park's Butterfly Garden. Queens live in low desert to wooded mountain areas, migrating just a bit to avoid freezes. Another Orange County site with a butterfly area is Gibbs Park in Huntington Beach's Central Park. An enclosed Butterfly House is featured at the Environmental Nature Center in Newport Beach. (Courtesy OC Parks.)

**CALIFORNIA GNATCATCHER.** This little bird makes headlines wherever it is spotted. Its rarity accords it threatened status. It is a year-round inhabitant of coastal sage scrub areas, where development is minimizing its hopes for survival. Seldom seen by hikers, this songbird that "mews" is found only along the Southern/Baja California coast. It is pictured beside another endangered species—dudlea stolonifera, a succulent found only on local cliffs. (Drawings by Warren Schepp.)

**CACTUS WREN.** Wildfires in county canyons severely affected this bird that nests only in cactus of certain height and thickness. The Irvine Ranch Conservancy has constructed "cactus condos" of green pipes and twisted wires to buffer the loss. Numbers of this insect eater have dwindled, making it a "species of concern." Cactus wrens favor coastal sage scrub areas, nesting in prickly pear cactus when desert cholla is not present. (Drawings by Warren Schepp.)

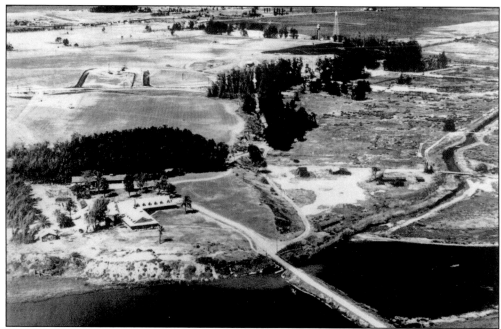

**BOLSA CHICA DUCK HUNTING.** A 1960s aerial view reveals this coastal site's historic use. The large complex was a gun club lodge built in 1899. It drew hunters to pursue the plentiful resident and migratory ducks. The ocean inlet was dammed, eliminating tidal input to improve hunting. One of the club's rowboats that carried well-armed hunters quietly to duck blinds throughout the marsh is seen below in the neglected grass. The lodge burned down in 1965. As time passed, the site was prime for commercial development. California acquired 300 acres in 1973 and built a levee, restoring 210 acres of the damaged wetlands. For three decades, plans for the remaining marsh were considered and legal battles fought, with the Amigos de Bolsa Chica conservation group emerging to advocate major restoration. (Above courtesy First American Title; below courtesy Amigos de Bolsa Chica.)

WETLANDS RESTORATION. The 300-acre Bolsa Chica Ecological Reserve was created in 1978. However, those acres waited until this century to become part of a success story. A majority of the 1,550-acre site was yet to be revitalized. In 2004, restoration of 590 acres began. In 2006, an ocean entry was cut, allowing the first direct seawater flow into the wetlands in a century. That twice-daily tidal flood has visibly stimulated marsh plant growth (below). Sand dredged from the site is nourishing Bolsa Chica State Beach. Restoration created new hope for endangered species like the least tern and clapper rail. Paths around the waterways and bird identification panels (above) give birdwatchers a "new" natural site and shore birds a new home on outer mud flats seen here. The successful project is the largest coastal wetland restoration ever undertaken in Southern California. (Both courtesy Dave Carlberg, Amigos de Bolsa Chica.)

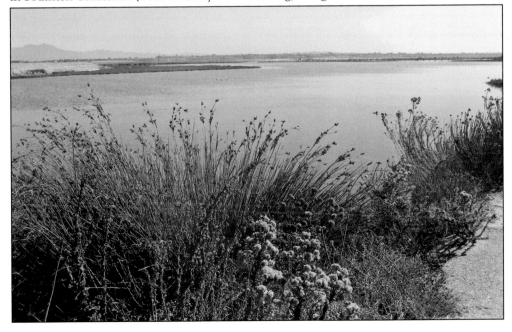

**BANDING BABY LEAST TERNS.** An active military base seems the "least" likely place for a baby least tern to hatch. However, at the Seal Beach Naval Weapons Station, this species is part of the strategic plan. Within the base is a 911-acre national wildlife refuge, meant to protect these birds as the navy does the coast. Endangered terns nest in beach sand within the tidal salt marsh. The refuge, like a good hotel, readies the sites for its spring arrivals. Least, meaning smallest, tern chicks are banded (above) so migratory patterns can be traced. Their present population is the "least" in years. Adults (below) use a fenced-off area called Tern Island to nest. It was called NASA Island when Saturn rocket boosters were made there in the 1960s. (Left courtesy U.S. Navy, Bob Schallmann; below courtesy U.S. Fish and Wildlife Service, Kirk Gilligan.)

**CARING FOR CLAPPER RAILS.** The Seal Beach Naval Weapons Station has received several federal awards for its successful wildlife refuge. The least tern and clapper rail are two of California's most threatened bird species. Above right, a juvenile light-footed clapper rail is banded at the refuge. Below right, an adult rail—a narrow bird—maneuvers through the dense cordgrass of this saltwater marsh in Anaheim Bay. The rail is a secretive species, seldom seen although a year-round resident. Its clicking cry is responsible for its name. Since 1972, this wildlife refuge has hosted a successful nursery for clapper rails, constructing rafts upon which the birds build their nests. The nature center displays sample nests and bird specimens for close-up identification. Birds migrating along the Pacific Flyway often winter there. (Above right courtesy U.S. Fish and Wildlife Service, Kirk Gilligan; below right courtesy Wildlife Refuge volunteer Tim Anderson.)

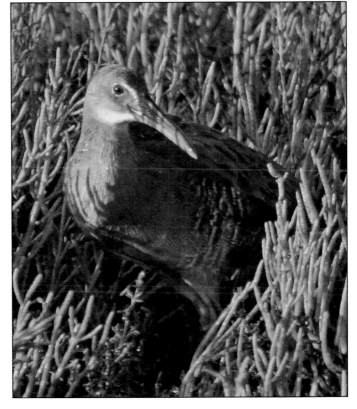

**Two-Spot Octopuses.** One common creature of local offshore waters became a star at Dana Point's Ocean Institute when she hatched 300 babies. The tiny 4-millimeter octopuses can reach 3 feet in length and have a life potential of about two years. During that time, they are cared for by aquarists while offering students the rare chance to study these "neighbors" up close as they mature. (Courtesy Linda Blanchard, Ocean Institute.)

**Jellyfish Nursery.** Studying the oceanic life cycle of moon jellyfish is a key to the Ocean Institute's Living Systems Lab, where different age groups of transparent moon jellies live and grow in progressive tanks. Jellyfish have a complex life history involving multiple metamorphoses. They have no heart, brain, spine, or bones, moving by pulsating their bells. They hunt prey with specialized stinging cells. (Courtesy Julianne Steers, Ocean Institute.)

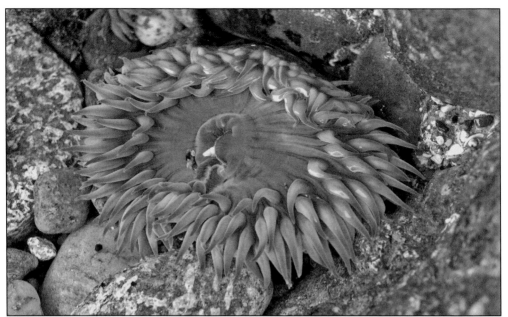

TIDE-POOL SECURITY. Orange County tide-pool life from Newport Beach through Dana Point is protected within several marine life refuges. This includes sea anemones (pictured), starfish, sea urchins, shellfish, and all sea life. Even empty shells are hands-off to visitors. Regulatory agencies are the California Fish and Wildlife Service and the County of Orange. The Ocean Institute educates students to investigate this habitat using low-impact exploration techniques. (Courtesy Julianne Steers, Ocean Institute.)

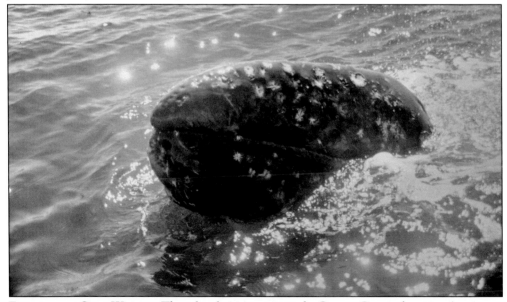

ENDANGERED GRAY WHALES. These loyal visitors migrate by Orange County between Arctic seas and Mexican wintering lagoons. Now California's official marine mammal, they have enjoyed federal protection since 1938. Their numbers have increased since whaling days yet are still unstable. No other whale follows a coast so closely. No other mammal migrates so far—6,000 miles each way. Dana Point's Festival of Whales honors them annually. (Photograph by the author.)

GROWING LAGUNA GREENBELT. The dream of bookstore owner Jim Dilley took a decade to come true, but in 1979, Laguna Beach bought his vision of a greenbelt, Sycamore Hills. Laguna Greenbelt, Inc., took on the task with protests and lawsuits against development of other prime natural parcels. A city tax measure passed by 80 percent of voters—added to county and state funds and an Irvine Company donation—has created an 18,000-acre belt of parks and preserves: Laguna Coast and Aliso/Wood Canyons Wilderness Parks, Crystal Cove State Park, and the Nature Reserve of Orange County. Laguna Greenbelt, Inc., has stayed active along the way, initiating public tours of the land and creating self-guiding nature trails from canyon bottom to ridgeline. It also maintains a grant program for student field trips. Devoted volunteer service accomplished so much. (Photographs by the author.)

**HORTENSE MILLER GARDEN.** When she died at 99, Hortense Miller was recognized for creating one of the nation's best private gardens. In the 1950s, she and her husband, Oscar, bought hillside property in Laguna Beach. She planted it with 1,500 species, working it until age 93. She deeded her 2.5-acre life work, a mix of native plants and hybrids, to the City of Laguna Beach for public tours. Hortense told her visitors, "I don't boss the garden. I merely put plants in the ground and let them do as they wish. They know how to grow better than I do, and far more beautifully. (Photograph by the author.)

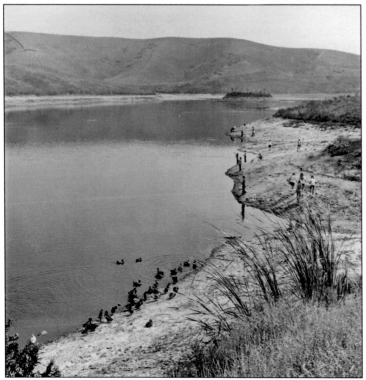

**CREEK CONNECTIONS.** When Laguna Niguel Lake was created, a small island bird refuge was constructed within it (background right). Today bird-watching competes with fishing in this Sulphur Creek Reservoir. Now that city has restored natural habitat along Sulphur Creek itself. Concrete was replaced with rocks along the channel. Native plantings, sycamores to sage, were added within Crown Valley Community Park, which also holds the Niguel Botanical Preserve. (Photograph by the author.)

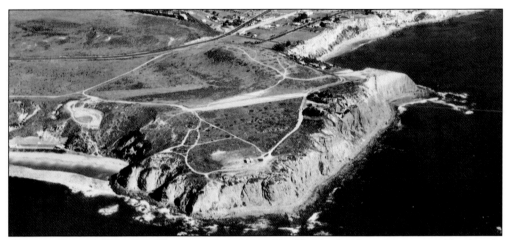

**ORANGE COUNTY NATURAL WONDERS.** Dana Point Headlands, the distinctive coastal landmark, was chosen Orange County's favorite natural wonder in a 2009 readers' poll conducted by the *Orange County Register*. The ancient bedrock promontory scored well ahead of second place Saddleback Mountain. The forces of ocean water earned Newport's surfing wonder, the Wedge, third place. Inland Caspers Wilderness Park ranked fourth. A more obscure landmark, visible on a sturdy hike in rainy season, was fifth: Holy Jim Waterfall. Sixth place was earned by the unnaturally transplanted but thriving Redwood Grove in Carbon Canyon Regional Park. The chosen seventh wonder was Red Rock Canyon in Limestone Canyon Wilderness Park. These choices represent a wide overview of Orange County's diverse natural elements!

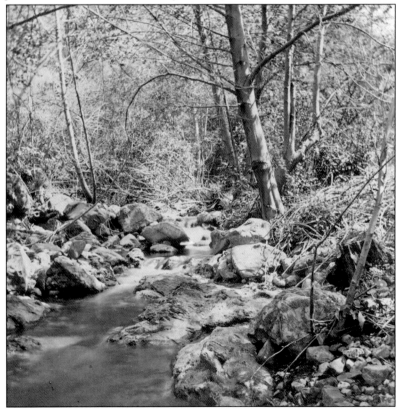

# A NATURAL FUTURE

Thoughts of the future take us back to the beginning—remembering that Orange County is the second-most biologically diverse county in California, but also one of the smallest and most densely populated per square mile. Its remaining wild lands and assets are extraordinary but may have a limited future. Many groups and agencies, with specific areas of concern, are working to preserve Orange County's natural future for all of us. Orange County Wild is an overlying coalition of environmentally conscious entities that have as their mission statement: "To proactively develop and implement a cohesive strategy to preserve, protect, and enhance our wildland forest, park, and reserve resources, from the mountains to the Pacific." See www.orangecountywild.com and its informative member links. Individual entities include:

### PUBLIC PARKS AND PROPERTIES
California State Parks
Cities of Orange County
Cleveland National Forest
Orange County Parks

### PRESERVES, CONSERVANCIES
Coyote Hills East Preserve
Dana Point Headlands Preserve
Donna O'Neill Land Conservancy
Huntington Beach Wetlands Conservancy
Irvine Ranch Conservancy
Laguna Greenbelt, Inc.
Rancho Mission Viejo Land Conservancy

### ENVIRONMENTAL AGENCIES
California Native Plant Society
Coastal Greenbelt Authority
Laguna Greenbelt, Inc.
Nature Reserve of Orange County
The Nature Conservancy
Ocean Institute
Santa Ana Mountains Association
The Sierra Club
Surfrider Foundation

### NATURE INTERPRETIVE CENTERS
Environmental Nature Center
Muth Interpretive Center
Nix Nature Center
Oak Canyon Nature Center
Shipley Nature Center
Tucker Wildlife Sanctuary

### WILDLIFE PROTECTION
American Cetacean Society
California Department of Fish and Game
Marine Mammal Center
National Audubon Society
Orange County Zoo
Pacific Wildlife Project
San Joaquin Wildlife Sanctuary
Seal Beach Wildlife Refuge
Starr Ranch Sanctuary
U.S. Fish and Wildlife Service
Wetlands and Wildlife Care Center

And other groups that may emerge to join this local challenge.

# DISCOVER THOUSANDS OF LOCAL HISTORY BOOKS FEATURING MILLIONS OF VINTAGE IMAGES

Arcadia Publishing, the leading local history publisher in the United States, is committed to making history accessible and meaningful through publishing books that celebrate and preserve the heritage of America's people and places.

## Find more books like this at
## www.arcadiapublishing.com

Search for your hometown history, your old stomping grounds, and even your favorite sports team.

Consistent with our mission to preserve history on a local level, this book was printed in South Carolina on American-made paper and manufactured entirely in the United States. Products carrying the accredited Forest Stewardship Council (FSC) label are printed on 100 percent FSC-certified paper.

MADE IN THE USA